DALI

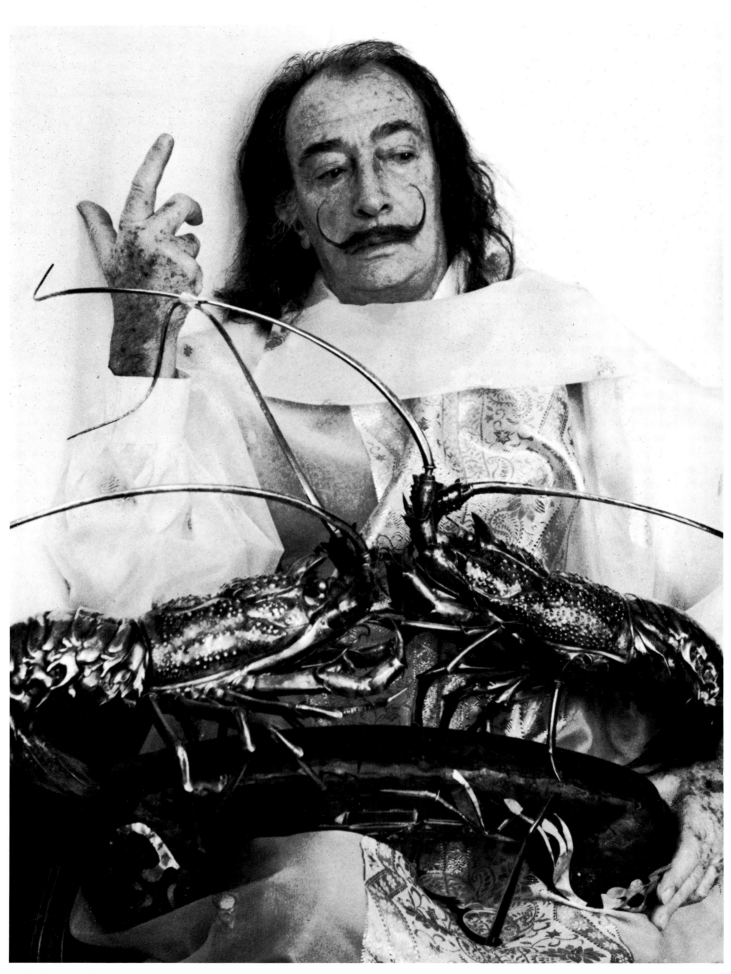

1. Dali at the Saint Regis Hotel, New York, March 1973

SALVADOR

DALI

TEXT BY

ROBERT DESCHARNES

TRANSLATED BY ELEANOR R. MORSE

HARRY N. ABRAMS, INC., *Publishers*

2. Dali's signature for an object; 1972, white wax

Photographs by Robert Descharnes and Enrique Sabater

ISBN 0-8109-0830-1
Library of Congress Catalog Card Number: 84-71112

Published in 1985 by Harry N. Abrams, Incorporated,
New York. Also published in a leatherbound edition
for The Easton Press, Norwalk, Connecticut. All
rights reserved. This is a concise edition of Robert
Descharnes' *Dali*, originally published in 1976. No
part of the contents of this book may be reproduced
without the written permission of the publishers.

Printed and bound in Japan

CONTENTS

salvador Dali

It is not impossible that in the future the Surrealist view-point will prove more important to an understanding of the epoch and for writing its history than the activities of the members of the group studied in the limited domains of literature, poetry, painting, or politics. Dali's work as a painter cannot be evaluated apart from his behavior, that controversial subject of astonishment and admiration he offers the world: the art of being Dali!

His life is an uninterrupted series of fireworks, a continuous celebration which never ceases to intrigue him and to enchant others. He is perpetual motion personified, busy painting, drawing, sculpting, signing, and receiving or disposing of some new accessory to his daily mythology in his own surroundings. With humor on the surface of his mind and insolence to the limit of civility, in a cascade of thunderclaps, little actions, and great enterprises, but always intelligent ones, Dali watches over every instant of his life in order to be Dali.

"Every morning upon awakening," he writes in his *Le Journal d'un génie*, "I experience a supreme pleasure: that of being Salvador Dali, and I ask myself, wonder-struck, what prodigious thing will he do today, this Salvador Dali." And in the evening he falls asleep in the midst of his Dalinian continuity.

The double play of the spectacle that Dali offers himself and others draws him into a subtle sort of vertigo in which all the moments of his daily life take on an unbelievable intensity. Whether this exploitation of the smallest incident may be explained reasonably by his paranoiac-critical method, or whether it appears as a sort of spell beyond all reason, it is first and foremost the constant source of all his great ideas.

His unprecedented luck has become a superstition, his intelligence mixes good sense and paradox in an explosive manner, and his rapidity of mind leaves the most intelligent behind. With these, he creates and re-creates ceaselessly, he provokes and incites defiance. Dali himself never recovers from being Dali, even if he is rather accustomed to say that he does not understand how others cannot be Dali. He must always be at the peak of his role, and this extreme exigency is the rigor of his life.

Not content merely to display his genius in his daily life, he also puts it into his works. One only needs to see *Christ of Saint John of the Cross* in the Glasgow Art Gallery and Museum (colorplate 35) and *Metamorphosis of Narcissus* in the Tate Gallery (fig. 37) to realize that he is a great painter. It is only necessary to read his autobiography, *The Secret Life of Salvador Dali*, to know that he is

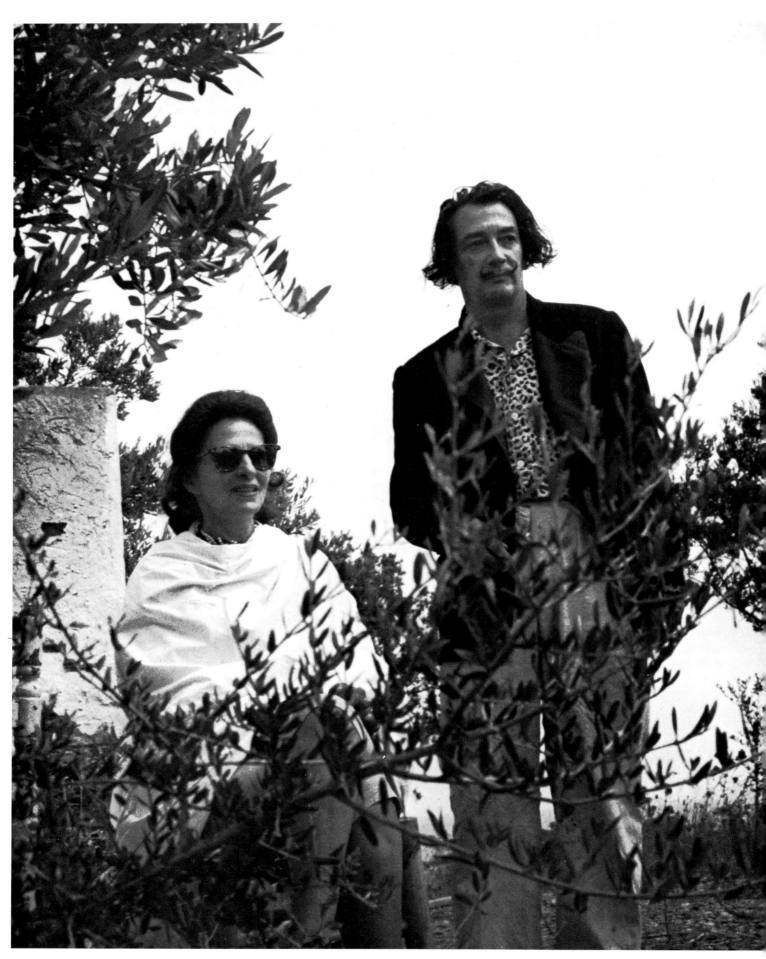

3. Dali and Gala in Port Lligat, August 1957

also an excellent writer. His jewelry alone would have made him famous. His furniture designs put him well ahead of interior decorators, just as he is in the avant-garde with his films, his ballets, his works of art in glass, wax, soap, bronze, and his "found objects."

Dali's versatility, just like that of the artists of the Renaissance, manifests itself in several fields where he is helped by artisans whose language he speaks and whom he pushes to the extreme limits of their techniques. He says of himself that the jaws of his mind are in perpetual motion and that he possesses the universal curiosity of the man of the Renaissance.

Dali's genius, which would have been freely acknowledged had it flowered in the Renaissance, is today so out of the ordinary that it provokes our modern world of average bureaucrats. There are still many who misunderstand this provocation and protest that he is crazy. But more and more throughout the entire world his audience grows, the interest in him increases, and Dali, never ceasing to be Dali, doesn't stop imposing on the world his controversial Surrealist personality. It becomes increasingly difficult to ignore him, because he is a man of genius whose legendary traits are amplified today by the press and television. We may ignore his genius, persecute it, make fun of it, but the Homeric hero, the mythical figure, captures our attention and compels our admiration. Born in an iconoclastic epoch–that of Surrealism–companion of Paul Eluard, André Breton, and Marcel Duchamp, and also adolescent friend of Federico García Lorca, Dali has about him the aura of the prestige of this era on which today all eyes converge.

Dali brought his irrational Iberian heritage to the Surrealists, who were troubled by the exploits of their heroes and by internecine quarrels. He endowed Surrealism, as André Breton was to write, "with a weapon of the first caliber by giving it his paranoiac-critical method." Through this method he invited them to systematize confusion and to utilize the first irrational material (oneiric and subconscious) that the Surrealists would have been content merely to reproduce by automatic writing and the like. His book entitled *Le Mythe tragique de L'Angélus de Millet* is the most complete example extant of the application of the paranoiac-critical method. (I shall give a definition of this method later on, at the point when Dali arrives in Paris.)

Today Dali still proclaims himself a Surrealist, even if, since his exclusion from the group by Breton in 1934, he says more precisely, "The difference between the Surrealists and me is that I am a Surrealist." Not only this affirmation but also most of his public manifestations, which appear in the newspapers, prove it: the meeting of Vermeer's *Lacemaker* and the rhinoceros at the zoo in Vincennes, the long and cretinizing loaf of bread he carried about Paris while walking in a procession, the Rolls

Royce filled with cauliflower, the lecture he gave in London wearing a deep-sea diver's suit in which he nearly suffocated to death. However, Dali has incorporated his Surrealism into a vaster field of inquiry. He has added mysticism to his paranoiac-critical method, insufficient alone, in order to transcend an impotent subjectivity and to express objective reality. Next, he has been led to undertake a "conquest of the irrational" on these two planes. And the unconscious, decoded, allies itself with, or effaces itself in front of, an almost divine intuition.

From this point on we are not astonished any more by the numerous Dalinian paradoxes; at this level there are no more contradictions, only complementarity. The Apollonian and Dionysiac universes unite to form a totality: order in apparent disorder, fixity in ostensible mobility, unity in diversity, and the indivisible principle of verticality in a world seemingly formless.

Dali's work is an illustration of this vision of the world –a mixture of classic and baroque, of monarchy and anarchy. And Dali the anarchist greets His Excellency, Salvador Dali. His solid roots in the concrete permit Dali to keep his equilibrium. Abstraction and idealism are traps for the mystic. As Miguel de Unamuno used to say, "Realism is the coherence of mysticism."

Dali's Catalonian atavisms are largely responsible for his attachment to the material world which surrounds him. A Catalonian accords existence only to what he can eat, hear, touch, smell, or see. While one of his compatriots, the philosopher Francesc Pujols, compares the expansion of the Catholic Church to a pig that is fattened before being killed and eaten, Dali declares, Dalinizing Saint Augustine: "Christ is cheese, better yet mountains of cheese." Such is Dali's Catalonian heritage: a comestible delirium.

Dali is a Catalonian and wants to be a Catalonian. For him there is no more beautiful landscape in the world than his beloved plain of Ampurdán, where he first saw the light of day, and the Catalonian coast from Cape Creus to Estartit with Cadaqués in the middle, all bathed in the Mediterranean light. And it is still in Catalonia that he places the center of the world, very exactly, in the railway station at Perpignan. Dali even sees himself about to become the Catalonian archetype predicted by Francesc Pujols, who wrote, "When Catalonia is queen and mistress of the world...and we look at the Catalonians it will be as if we were looking at the blood of truth; when we shake hands with them, it will be as if we were touching truth's hand...because they are Catalonians all their expenses wherever they go will be paid."

We must infer from this that Dali's taste for money is also Catalonian, having its source in the Phoenician ancestors. We know that the anagram of his name, "Avida Dollars," discovered by André Breton during World War II, has brought him luck, because he has said so. He is

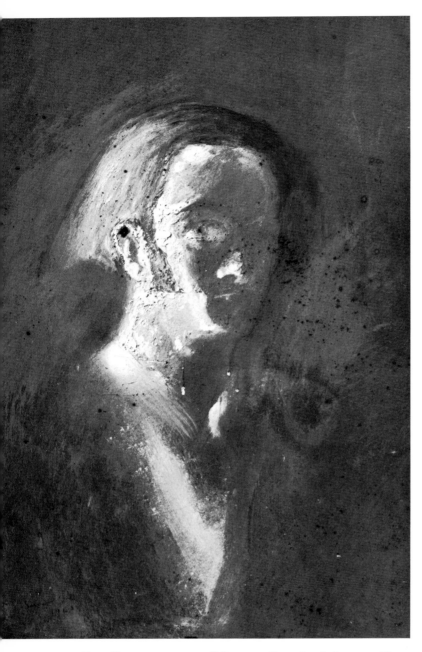

4. SELF-PORTRAIT. 1921. Oil on cardboard, 18½ × 11¼". *Fundación Gala-Salvador-Dali, Figueras*

at the same time, the perfect prototype of the Spaniard. Besides, Dali declares in his *Secret Life*, "The most important events which can happen to a contemporary painter are two in number:
1. To be Spanish
2. To be named Gala Salvador Dali."

Salvador Dali was born on the morning of May 11, 1904, in Figueras, a small town in the northern part of Catalonia, founded by the Phoenicians and dedicated to commerce. His father, Salvador Dali y Cusi, was the state notary, a dictatorial and passionate man but liberal-minded. He accepted without too many reservations the fact that his only son wished to become an artist. We must realize that at the beginning of the century his decision was aided by the intellectual and artistic climate of Barcelona, which had spread throughout Catalonia. This was the only Iberian province to have followed the rhythm of the industrial and cultural European revolution of the nineteenth century. It had, indeed, been going through an intense period of renaissance since 1860. The increase in economic trade with Germany, France, and England, as well as commerce and trips to the Antilles, Cuba, Mexico, and the Philippines, allowed ideas to cross the border. Money was plentiful, was in circulation, and was pouring out in torrents! The absolute power of the Catalonians who wished to make Barcelona the Athens of the twentieth century did not spring from a desire for conquest but rather from a conviction that the only authority is found in ideas. Dali likes to repeat that the Catalonians "did not deform reality, they transformed it." Briefly, what in any other Spanish province would have been impossible came to life and shone in Barcelona. In 1904 Picasso, who was then twenty-three years old, painted *Woman Ironing*, and the architect Antonio Gaudí built "the last living cathedral," La Sagrada Familia.

To every Catalonian, the country or the place which saw his birth is truly the center of the world. To make this place known, to bring it recognition and to glorify it, does not only mean that this fame must spread around the world but must also make the world turn. Eugenio d'Ors wished above all that Catalonia would play a role in European thought. Francesc Pujols declared that he himself was not a Catalonian separatist but really a tenacious partisan of Catalonian hegemony. As for Dali, it is a question not only of men but also of the privileged place par excellence when he exclaims, "Do you believe that, since the earth is round, you will find landscapes everywhere? Does a round face have several noses? There are very few landscapes. They all converge here. Catalonia is the nose of the earth!" In order to prove this there is no need for him to conquer any other land than his own: the plain of Ampurdán, swept by the Tramontana, which illuminates

rich, and money is for him the permanent and tangible proof of his success; in addition, it represents the possibility of an afterlife through hibernation, but especially important is the manifestation of the fascination that gold exerts over him. For Dali, gold is magic, when he exclaims in *Les Passions selon Dali:* "For a mystic like me, man is alchemic matter capable of being turned to gold," and he admits that one of his exhilarations while painting is to make gold.

Dali's passion for gold is as much Spanish as Catalonian. And Dali is proud of being a Spaniard. He was jubilant when Sigmund Freud saw him as a fanatic and,

the "most concrete and the most objective landscape in the world" with an incomparable light where the skies of Greece and Holland find themselves united.

Dali's father was born in Cadaqués, a little village on the coast about thirty kilometers from Figueras. This marvelous haven for fishermen which Federico García Lorca saw "counterpoised between sea and hill" was to share with the plain of Ampurdán the role of background, of prop, of stage curtain in the grand opera which was to be the life and work of the artist. And in order better to apply the brushstrokes on the stage setting for the great heights of his cosmogony, Salvador Dali started at an early age to portray there the profile of his silhouette, cultivating at the same time his behavior and his gifts for drawing and painting.

First, his behavior. He himself relates in his autobiography that he was a handsome child, temperamental and difficult, imposing his whims on his parents, who idolized him. At school in Figueras he spent more time developing his natural exhibitionism than trying to get good grades. Even as an adolescent, he began to adopt the attributes of the artist-dandy to enhance his image: bizarre clothing, sideburns, long hair, and a cane with a pommel. He started to paint when he was about eight years old. Quickly aided by his keen eye and an excellent memory, he joyfully seized upon the landscape and himself as subjects in *Self-Portrait in the Studio, Cadaqués* (fig. 5) and *Self-Portrait with the Neck of Raphael* (color-plate 2).

Now, painting. In spite of his liberalism, Dali's father would undoubtedly not have agreed so readily to his son becoming a painter if he had not been encouraged by his best friends, the Pichot family. Dali recognizes the capital role that this family played in his life: "My parents had already been subjected to the influence of the Pichots' personalities," he wrote in his *Secret Life*. "All were artists and possessed great gifts and sureness of taste. Ramón Pichot was a painter, Ricardo a violoncellist, Luis a violinist, María a contralto opera singer, Pepito was perhaps the most artistic of all," because for Dali he had a unique sense of nature and of life in general. Dali was exposed to Impressionism through the paintings of Ramón Pichot, which he saw at the Pichot home in Figueras, at their country estate called the Mill-Tower, and at their summer home in Cadaqués.

He remembers his sojourns at the Mill-Tower and his admiration for certain pictures with an increasing number of spots in which Impressionism was giving way to Pointillism. It was there that he attempted an extraordinary experiment; and he was only twelve years old! Short of canvas and wishing to paint a still life with cherries, he decided to use an old door, which had been dismantled and placed horizontally between two chairs, only painting the center so as to preserve intact the ornamental

5. SELF-PORTRAIT IN THE STUDIO, CADAQUÉS. c. 1919. Oil on canvas, 10⅝ × 8¼". *Salvador Dali Museum, St. Petersburg, Florida*

molding as a frame. He began the cherries, using three colors pressed by hand directly from the tubes: vermilion for the light, carmine for the shadow, white for the reflection. Animated rhythmically by the regular grinding noise of the mill, the picture became a fascinating game of skill which Dali completed with a collage of real cherry stems.

The still life and figure drawing occupy an important place in Dali's work. But the crucible in which he transforms beings and things, thus creating the most astonishing oneiric fresco of the contemporary epoch, is the landscape, the landscape of Cadaqués. It has always exercised a tremendous fascination over painters and writers. The secret emotional power of this particular place lies in its own geological structure. The town rises from the bottom of an enclosed bay, surrounded by terraced hills where grapes and olives used to be cultivated.

From 1920 to 1921, the vigorous impressionistic touch, without being quite abandoned, decreased and became pointillistic, giving way to the pursuit of color. The influence of the Fauves and of Bonnard is evident in such canvases as *Back View of Cadaqués* (fig. 9) and *Portrait of the Violoncellist Ricardo Pichot*. At the same time, the search to capture the feeling of the atmosphere became more precise, especially in the portraits. The shapes were toned down, and the intimate light of their nimbus is close to that which bathes the works of Eugène Carrière (1849-1906), the French painter and lithographer whose figures stand out against a foggy background. See, for instance, Dali's *Portrait of Grandmother Ana Sewing* and *Self-Portrait* (fig. 4).

But already Dali was using multiple styles, experimenting with several techniques at the same time, most of them mastered in a few months. Without abandoning the subjects on canvas, he began to work on cardboard, mixing gouache and oil. The distemper drawings, representing country scenes full of happiness, date from this period (see *Romería*, fig. 8). Toward the end of 1920 the works became abruptly impregnated with sadness; grays appeared, and the colors became muted. Dali was just then deeply feeling the disappearance of the being whom he cherished most in the world: "I had to achieve glory," he wrote later, "to avenge the affront caused me by the death of my mother, whom I adored religiously."

While finishing his studies at the school in Figueras, the young boy was perfecting his drawing by attending a night course. His professor, Juan Núñez, was an excel-

6. OLD MAN AT TWILIGHT. c. 1917-18.
Oil on canvas with collage, 19¾ × 11¼".
Private collection

7. View of Cadaqués

Turned toward the east, the site is like a true natural amphitheater which shows to advantage in any light. Its twilights with their distressing nostalgia hang heavy over the most beautiful of Dali's Surrealist paintings.

The influence of Impressionism is clearly seen in the work of the young Catalonian artist up to 1919. Most of the pictures of this period were painted in oil at Cadaqués, where he spent all his summers. There his parents owned a vacation home right on the beach. The canvases depict the town with its fortified church, the coves and the olive trees, scenes of daily life, peasant women, and, of course, the fishermen, both young and old, similar to *Old Man at Twilight* (fig. 6), where the atmosphere of the sky laden with clouds was obtained by the use of little stones glued to the canvas and then painted with different colors.

lent engraver. Recognizing the exceptional gifts of his youthful pupil, he took him home after the course, revealing the secrets of watercolor technique to the boy.

The notary Dali had decided that his boy should pursue his art studies at the San Fernando Academy of Fine Arts in Madrid, in order to obtain a diploma as professor of drawing. Having passed the entrance examination, Dali was comfortably installed by his father at the Residence, a pension for well-to-do students. During the first months in Madrid he divided his time between the courses at the Academy and his painting, practically not going out at all. Influenced by Juan Gris, Seurat, and the

8. (*Right*) ROMERÍA. c. 1921. Gouache on cardboard, 20½ x 20½". *Collection Joseph Llongueras Gali, Barcelona*

9. (*Below*) BACK VIEW OF CADAQUÉS. 1921. Oil on canvas, 16½ x 20⅞". *Private collection*

13

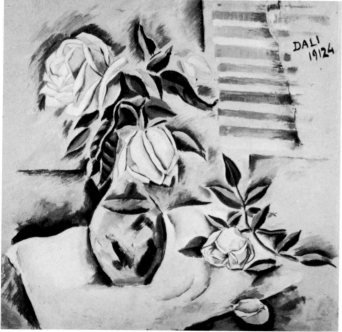

10. (*Above*) CADAQUÉS. 1923. Oil on canvas, 37⅜ × 49⅛".
The Salvador Dali Museum, St. Petersburg, Florida

11. (*Left*) BOUQUET OF FLOWERS. 1924.
Oil on cardboard, 19⅝ × 20½".
The Salvador Dali Museum,
St. Petersburg, Florida

Italian Metaphysical School, he then painted his first
Cubist works, in which he used only black, white, sienna
red, and olive green, thus reacting against the vivid tones
of the preceding years.

Dali was quickly disappointed in the teaching at the
Academy. The professors were just becoming aware of
such novelties as Impressionism blended with its Span-
ish equivalent, which he had outgrown a year earlier in
1920, when, in the magazines to which he subscribed,
such as *L'Esprit nouveau*, he had seen the Cubist paint-
ings of Picasso, the work of Carlo Carrà, and had read the

14

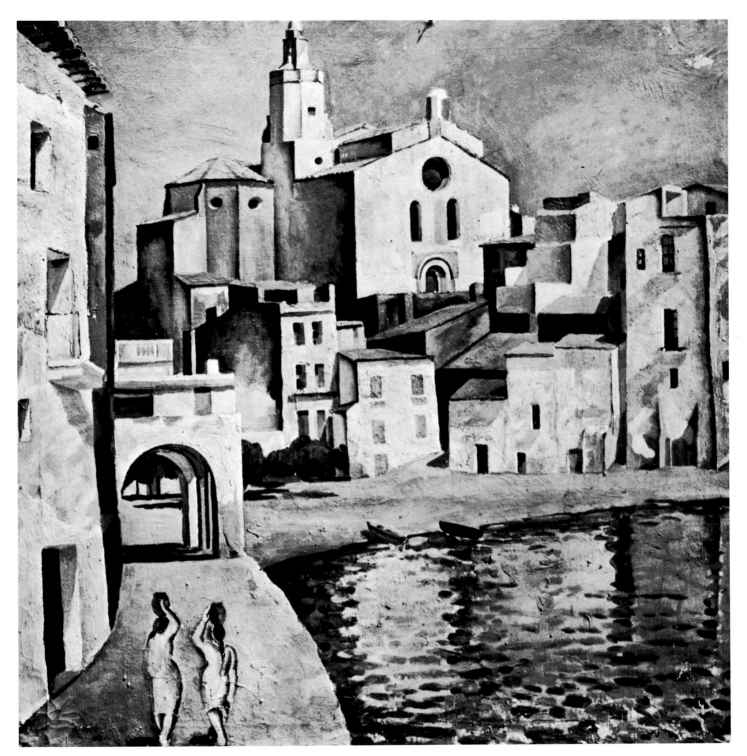

12. Port Alguer. 1924. Oil on canvas, 39⅜ × 39⅜".
Fundación Gala-Salvador-Dali, Figueras

definition of Purism. The students at the Residence formed groups according to their diverse tendencies. Dali, emerging from his reserve, joined with the most avant-garde of all: Pepín Bello, Federico García Lorca, Luis Buñuel, Pedro Garcías, Eugenio Montes, and Raphael Barades.

In 1923 Dali was suspended for a year from the San Fernando Academy, following incidents occurring because of the appointment of a new professor of painting. Dali was accused of having incited the students to riot against the choice of a mediocre artist. Returning to his family, Dali, who already flaunted perverse ideas — although being apolitical, as he has remained all his life — was arrested and imprisoned for a few weeks in Gerona. The authorities took a dim view of the fact that

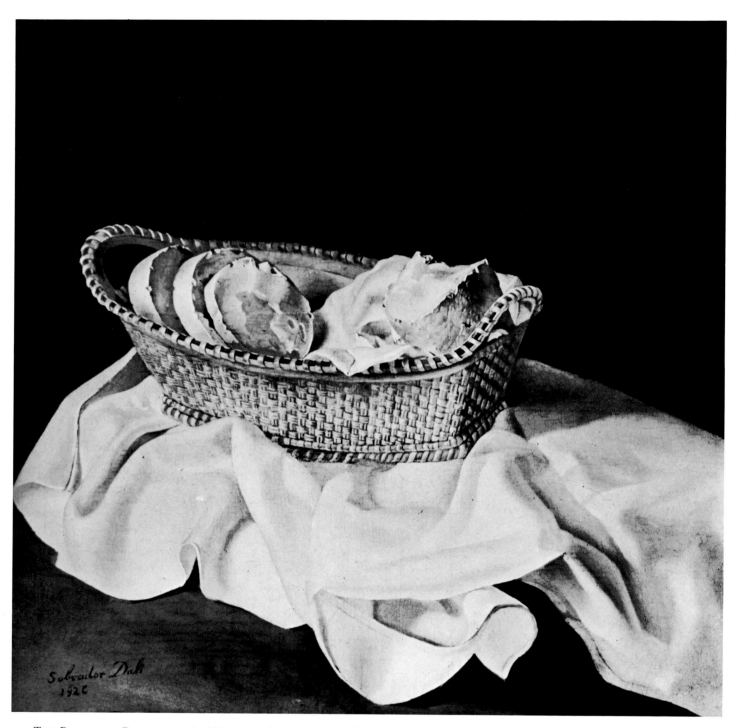

13. THE BASKET OF BREAD. 1926. Oil on panel, 12⅜ × 12⅜".
Salvador Dali Museum, St. Petersburg, Florida

the only inhabitant of Figueras who had a subscription to the French communist newspaper *L'Humanité* was the son of the state notary, especially when this notary himself did not hide his regrettable sympathy for the Catalonian separatist movement. During the months preceding his expulsion from the Academy, Dali had led a tumultuous life in Madrid in the company of his friends. In con-

trast, he was happy to be back in Cadaqués again, where he lived an ascetic life, spending long days devoted entirely to reading and painting.

In 1924, pursuing his experiments of the year before — as in *Cadaqués* (fig. 10) — and his thorough studies in composition, he was at the same time working on Cubist and Purist canvases, such as *Bouquet of Flowers* (fig. 11), as well as figurative landscapes — for instance, *Port Alguer* (fig. 12) — quite similar to those that Derain and Waroquier were painting at that period. In the autumn

of 1925, Dali returned to the San Fernando Academy, but was permanently expelled on October 20 of the following year.

But 1925 brought to the young man more than his return to a school in which he felt there was nothing further to learn: his first one-man show in Barcelona and visits from Federico García Lorca. That summer Dali painted a series of portraits and landscapes, all luminous and barren — such as *Portrait of the Artist's Father* (colorplate 4) and *Girl Standing at the Window* (colorplate 5). In November Lorca made a second visit to Cadaqués and to Figueras. This old friend from the Madrid pension who "sparkled like a diamond" quickly won the hearts of Dali's father and sister by reading his poems and the story of his play *Mariana Pineda* to them. Dali's pictures of the summer were exhibited at the Dalmau Gallery in Barcelona on November 14-27. At the end of the following year, the same gallery displayed *The Rocks of Llaner, Figure on the Rocks — Penya Segats, Venus and Cupids,* and *The Basket of Bread* (fig. 13), which became the first

painting by Dali to be shown abroad, at the Carnegie International Exhibition in Pittsburgh in 1928.

The Catalonian critics gave the Dalmau exhibition a warm reception. One of them wrote in *D'Aci d'alla* in the January 1926 issue: "Rarely does a young painter appear with so much aplomb as this Salvador Dali, child of Figueras.... If Salvador Dali has turned his face toward France, it is because he can do it, because the gifts for becoming a painter that God gave him must have time to ripen. What difference does it make if Dali uses a lead pencil like that of Ingres or large wooden pieces from the Cubist works of Picasso to revive the fire."

From Dali's return to Madrid in the autumn of 1925 until the end of 1927, the friendship between Federico García Lorca and Dali continued to grow. Undoubtedly each one of the young men found in the other a passion for aesthetic discovery equal to his own desires. In 1927 the maturity of Dali's works — he was then only twenty-three years old — was evident. One need only look at *Blood Is Sweeter Than Honey* (fig. 14), *Apparatus and*

14. BLOOD IS SWEETER THAN HONEY. 1927. Oil. *Whereabouts unknown*

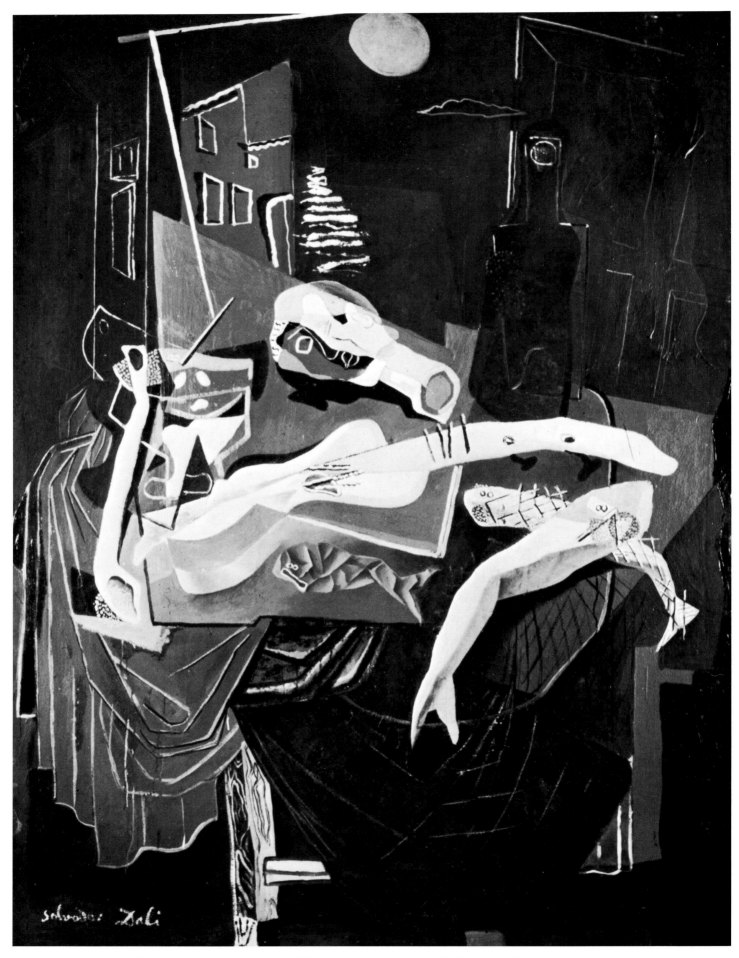

15. STILL LIFE BY THE LIGHT OF THE MOON. 1927. Oil on canvas, 75 × 55 1/8″. *Private collection*

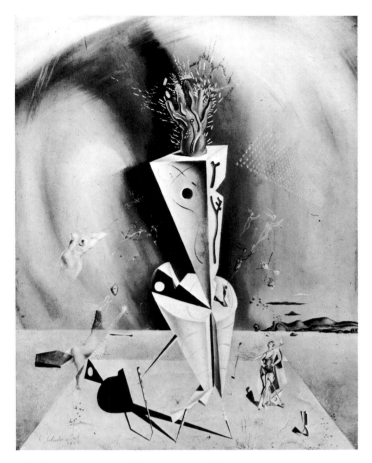

16. APPARATUS AND HAND. 1927. Oil on panel, 24½ × 19".
Collection Mr. and Mrs. A. Reynolds Morse, on loan to Salvador Dali Museum, St. Petersburg, Florida

The steel compass recites its short elastic verse.
The sphere already contradicts unknown islands.
The straight line expresses its vertical effort
and the wise crystals sing their geometries.

(Stanzas 18 and 19)

Pure rose that cleans away subterfuges and sketches
and opens to us the tenuous wings of its smile...

(Stanza 21)

Oh Salvador Dali of the olive-toned voice!
I say what your person and your pictures say

to me...

(Stanza 22)

The intensity, strictness, and imagination are so real in Dali's works of this period that one is stupefied to read in *Surrealism and Painting* by André Breton: "When Dali was introduced to Surrealism in 1929, his previous works rigorously said nothing personal." Today, we are able to perceive the limited, partial, indeed almost blind aspect of such an affirmation. This demonstrates a mis-understanding of Dali's attitude toward reality. Can we consider Picasso's works prior to Cubism, which were influenced by the Catalonian painter Nonell, as imper-sonal? From 1926 on, long before he met the Surrealists,

17. FEMALE NUDE. 1928. Oil on canvas
with cork float and string. *Private collection*

Hand (fig. 16), or *Inaugural Gooseflesh* (colorplate 10) to discover in these early oils the true genetic code of all the following works.

In 1925, Lorca had dedicated a dazzling ode to his friend. Though it was first entitled *Didactic Ode to Salva-dor Dali*, the adjective "didactic" quickly disappeared. The ardent stanzas of this long poem written in halcyon alexandrine verse tell of the friendship between the poet and the artist. Lorca praised the tenacious, lucid, and calculated investigations of the young Apollonian painter and also passionately placed in opposition to these his profound love of the human being and the sim-ple perfection of the rose:

A rose in the high garden that you desire.
A wheel in the pure syntax of steel. *(Stanza 1)*

You love matter defined and exact
where a mushroom cannot raise its tent.
You love architecture which constructs in absentia
and you take the flag as a simple joke.

18. FISHERMEN IN THE SUN. 1928. Oil on canvas with strings,
39½ × 39½". *Private collection*

Dali increased his research work, employing again techniques already mastered in 1924 — Impressionism, Pointillism, Futurism, Cubism, and Neo-Cubism, to which he added the prowess acquired the preceding year while working on canvases such as *Portrait of the Artist's Father* (colorplate 4) and *Girl Standing at the Window* (colorplate 5).

Dali's great clairvoyance was, undoubtedly, never to try to bring together in the same picture all the knowledge acquired before. Just the contrary: in works painted at the same time, he always knew how to pick the elements for the composition, the right brushstroke, the harmony of colors, the exact details — briefly, everything that permitted him to make a step forward without wasting time, energy, or materials, all along treating each particular subject with the greatest efficacy. Of course,

all the influences were perfectly visible, but they were only springboards for depicting in images what he had to say.

He took momentarily from each one what he needed, but aside from observations and investigations into the methods of other artists what he borrowed from them never occupied him for more than a few weeks. If in 1926 and at the beginning of 1927 the influences were still very diversified — *Reclining Woman* (colorplate 6), *Still Life by the Light of the Moon* (fig. 15), *Barcelonese Mannequin* (colorplate 7) — as early as the summer of 1927, until spring of 1929, his works owe little to others. We can group them into three categories. First, the measure of man's universe and his sensations, of which *Blood Is Sweeter Than Honey* and *Inaugural Gooseflesh* are good examples. Next, the use of matter as totalitarian hierarchy, with the help of collage: cork floats, incorporated objects, sand and gravel, strings and sponges. Here we already uncover the violent desire to create objects charged with contemporary sexual symbols. Several of these works when shown in Barcelona caused a scandal, among them *Female Nude* (fig. 17) and *Unsatisfied Desires* (colorplate 9). Finally, a series of ideographic canvases still unknown today, since most of them have disappeared, whose utilization has remained a hidden constant, present in all Dali's works. Their calligraphy is inspired (see *Fishermen in the Sun*, fig. 18) and assures communication among the painter's eye, the writer's pen and the poet's words, because Dali's activities are by no means limited to painting alone. They were evident in Barcelona, where Dali collaborated on several literary and artistic avant-garde magazines. Certain of his writings, such as "Saint Sebastian" in rhythmic prose, which aroused Lorca's enthusiasm, already potentially contained all the analytical Iberian irrationalism which later greatly disturbed the French Surrealist movement.

It was probably at the beginning of 1927 that Dali spent his first week in Paris, "marked," he says, "by three important visits: Versailles, the Musée Grévin, and Picasso." In autumn of 1928 his old friend Luis Buñuel came to Figueras, where he and Dali wrote the scenario for the best-known Surrealist movie, *Un Chien Andalou.* Dali made his second trip to Paris in 1928 in the company of his compatriot Joan Miró. It was then that he met the Surrealists and made a tour of the most famous brothels in the capital, later reaching these conclusions: "The three places which have produced upon me the deepest impression of mystery are: the stairway of the 'Chabanais' [one of the most famous brothels in Paris, on rue Chabanais], the Theater of Palladio in Vicenza, and the entrance to the tombs of the kings of Spain in the Escorial, because for me eroticism must always be ugly, the aesthetic always divine, and death beautiful." The young Catalonian painter's personality so greatly intrigued his

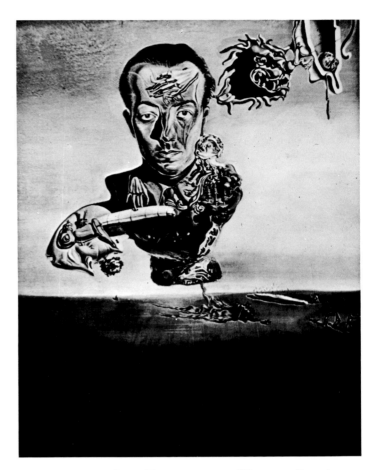

19. PORTRAIT OF PAUL ELUARD. 1929. Oil on cardboard, 13 × 9⅞". *Private collection*

new friends, Paul Eluard and René Magritte, that they decided to pay him a visit in Cadaqués the following summer.

The meeting of Dali with the Surrealists in 1928 was less important in itself than the historians of the movement care to admit. If, just then, the painter was at a turning point in his life, first it was because his research work of the preceding years had led along a parallel path with the quests of Lorca in a climate where friendship had given way to the loving passion of the poet of Granada, which greatly upset the painter. Dali did not hesitate to write later concerning this episode in *Les Passions selon Dali:* "When Lorca tried to seduce me, I refused with horror." Second, because Dali's desire to satisfy his erotic reveries, already well systemized if not completely dominated, did not estrange him from women, even though at twenty-four he was no longer virgin, his amorous experiences with women still remained limited and far behind the love affairs conjured up by his vivid imagination. Finally, it was because, armed with exceptionally rich, imaginary baggage, considering he had accumulated it in less than ten years, Dali felt himself pushed in spite of everything to discover more, beyond Catalonia, beyond Spain, just as much as to make himself known

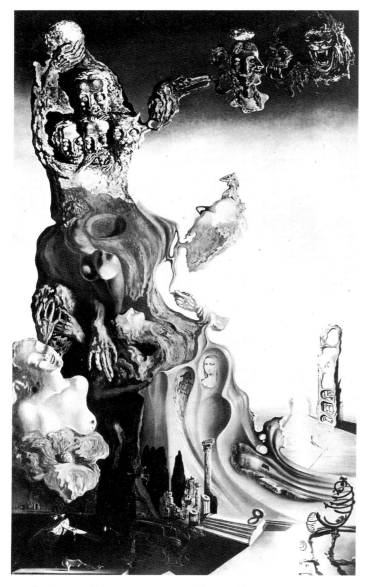

20. IMPERIAL MONUMENT TO THE CHILD-WOMAN. 1929. Oil on canvas, 56 × 32″. *Private collection*

using methods with which he had experimented successfully in the intellectual and artistic circles of Barcelona.

However, the conquest of Paris did not begin in a triumphal way when Dali went there for the second time during the winter of 1928. *Un Chien Andalou*, not yet finished, seemed mediocre to him; it did not have enough rotting donkeys to suit him. Paris was full of traps, and "I had not succeeded," he writes in his *Secret Life*, "in finding a woman, elegant or not elegant, who would agree to lend herself to my erotic fantasies."

Ill-at-ease and bitter, he preferred to flee from Paris, and it was with a tremendous sigh of relief that he went back to Catalonia. However, in spite of his joy at returning to the beloved light of Cadaqués, he felt working inside him a profound change. For the first time, everything that had happened during the preceding

years, even including the sojourns in Paris, disappeared to give way to images that he could not localize although he was certain that he had seen them during his childhood. Figures crowded his mind, similar to decalcomanias, with such clear contours and definite colors that it was easy to draw them first in order to organize and paint them later.

The paintings from the beginning of 1929 are small. They were all done in oil with collage on panels of olive wood, made by a carpenter of Cadaqués who went on preparing such panels for Dali for more than thirty years. The most notable of these are *The Lugubrious Game, Illumined Pleasures* (fig. 59), *The Accommodations of Desire*, and *The First Days of Spring*. These works can be considered products of Dali's first Surrealist period. André Breton recognized that nothing of such a revelatory nature had appeared since the works of Max Ernst in 1923 and 1924, such as *Pietà or Revolution by Night*.

For the first time, using with diabolical ease a mastery of all his techniques, Dali decided to paint "*trompe l'oeil* photographs" of his dream images. This depiction was to remain a constant of his life. In 1973, he again repeated, having improved his definition, what he had first said in 1935 in *Conquest of the Irrational:* "Photography in three dimensions and in color of the superfine images of concrete irrationality entirely made by hand." We are perfectly aware today of the content and explosive force of the pictures painted during that period; the poetic intensity as well as their visionary character project them into the future and already make of Salvador Dali an artist whose Surrealist adventure, begun in 1929, was to continue beyond the middle of the century.

The year 1929 brought him something other than the sole pleasure of painting canvases. These, although sumptuous and upsetting, in other respects left him unsatisfied. Indeed, during the summer he received a telegram from his dealer, Camille Goemans, with whom he had signed a contract the winter before, giving him the exclusive rights to all his summer production. The message brought good news: Goemans intended to exhibit all the pictures in his Parisian gallery that fall and was announcing his forthcoming arrival. It was the first time that the young Catalonian could hope to receive money as a painter. In a few days Camille Goemans arrived in Cadaqués, having come to see *The Lugubrious Game*, accompanied by René and Georgette Magritte with Luis Buñuel. Later Paul Eluard and his wife, Gala, arrived.

During this period of his life Dali was frequently afflicted with attacks of violent laughter accompanied by spasms. He himself relates how his father, hearing him from the garden and worried about his son's exaltation, stopped to remark, "What is wrong? It's that child laughing again!" This behavior of Dali's was surprising to his new Surrealist friends as well. In a few days he found

himself surrounded for the first time by a group which ran to him, attracted by his unusual personality as much as by the violent character of his works, which were full of sexual and scatological allusions. If Dali felt flattered by the coming of Eluard — mastermind of the Surrealist movement, along with André Breton and Louis Aragon, whom he had met only briefly the winter before in Paris — the appearance of Gala was a revelation to him. He found in her the imaginary feminine figure, Galutchka, companion of his childhood reveries. Gala had the same nude back. The description of Gala's anatomy given by Dali in his *Secret Life* is the same as that of most of the female figures depicted in his paintings and drawings: "Her body was as delicate as that of a child, her shoulder blades and lumbar muscles had that slightly brusque tension of adolescents. On the other hand, the hollow of her back was extremely feminine and gracefully linked the energetic and proud torso to the very fine hips which the waspwaist made even more desirable." During that summer no one imagined that a new and unusual couple, the couple Gala-Dali, Gala-Salvador Dali, was about to be born. Gala immediately showed a very lively interest in the artist, in his paintings and in the man himself.

Dali was working on larger canvases, such as *The Invisible Man* (fig. 21), *The Great Masturbator* (fig. 22), and *Portrait of Paul Eluard* (fig. 19), for which the poet posed several times. He divided his time among his new friends, his painting, and long walks in Gala's company by the rocks of Cape Creus with their planetary melancholy. In a cove at Es Cayals, he confessed his love to her. This was not an easy thing to do. Helena Dimitriovnie Diakonova, daughter of a Moscow lawyer and known to everyone as Gala, mingled with a fascinating charm an assurance which made a real impression on young Salvador. "This flesh," he was to write later, "so close to mine, so real, kept me from speaking. The childish beauty of her face was not the only elegant part of her body." During adolescence Gala had suffered from a pulmonary disease. "I kept looking at her chest thrown out by her victorious gait and said to myself with even then a touch of aesthetic humor, 'the face of victory is also clouded by ill-humor, one must not touch it.' However, I was going to touch it."

During the first days of September Dali found himself alone with Gala in Cadaqués. Their friends, accompanied by Paul Eluard, had gone back to Paris, where the young woman was soon to join them. He himself went to Figueras to work on some pictures started in the summer, to finish the portrait of Eluard, and to undertake two large canvases, *The Enigma of Desire: My Mother, My Mother, My Mother* (colorplate 11) and *Imperial Monument to the Child-Woman* (fig. 20). He put the finishing touches on the most important work of this period, *The Great Masturbator*. The main subject in it is a large, soft,

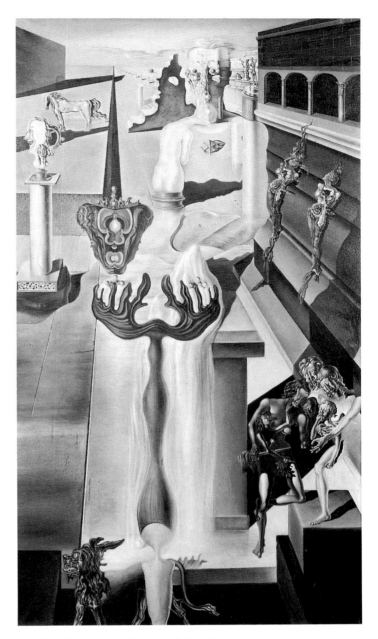

21. THE INVISIBLE MAN (unfinished).
1929. Oil on canvas, 56¼ × 31⅞".
Private collection

terrorized head, livid and waxlike, with pink cheeks; the closed eyes are embellished by very long eyelashes. A tremendous nose is leaning on the ground. The mouth, replaced by a decaying grasshopper crawling with ants, opens in the middle of a head finished off with ornamentation in the 1900 style. After a month of strenuous work in his studio he entrusted his paintings to a carpenter, overseeing their packing himself with maniacal care, to ship them later to Paris, where they were shown at the Goemans Gallery from November 20 to December 5, 1929.

Dali rejoined Gala. Together they attended a showing of *Un Chien Andalou*, which Buñuel had just finished

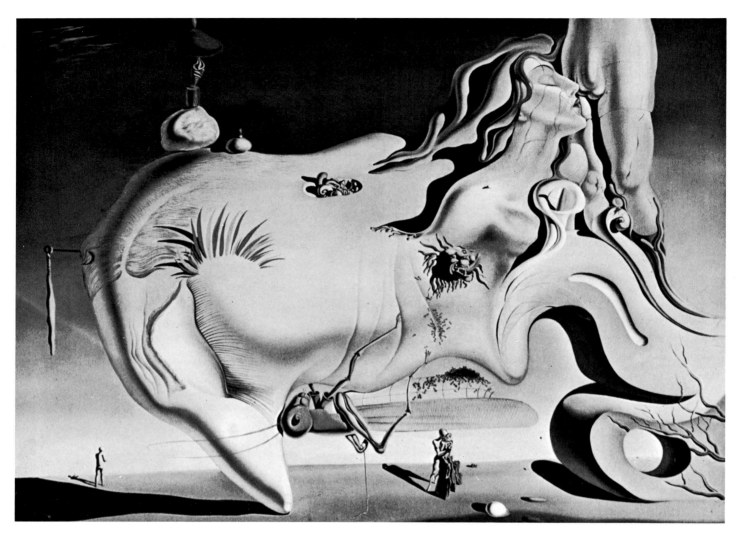

22. THE GREAT MASTURBATOR. 1929. Oil on canvas, 43¼ × 59". *Private collection*

filming, but as it turned out, they were not there for the vernissage of the painter's first Parisian exhibition. Madly in love with each other, they had left the capital two days before the opening to go to Sitges, a small seaside resort a few kilometers south of Barcelona. It soon became necessary to organize their newly begun life together, as well as to face certain material needs, since up to this time Dali had always lived with his parents. So Gala was obliged to return to Paris to see how the details of the contract which the painter had made with Goemans were being carried out. Untiringly Dali thanks Gala for having been "the vigilant helmsman who held the wheel of the ship of our life!" Meanwhile a storm was brewing in the family home.

During the few days Dali spent in Paris in November 1929, he had shown the Surrealists a Saint-Sulpicien chromo bought on the Ramblas in Figueras depicting the Sacred Heart, on which were written these words in his handwriting: "Sometimes I spit with pleasure on my mother's portrait." The Spanish art critic Eugenio d'Ors

wrote about this sacrilegious gesture in an article which was published in a daily newspaper of Barcelona. Dali's father took this blasphemy literally as an insult to the memory of his beloved first wife and his son's dead mother. He was much more outraged by this than by the scandalous liaison of his son with a married foreign woman. Therefore, when the young man put Gala on the train for Paris and returned home, his father burst into a violent rage.

During the exhibition at the Goemans Gallery several paintings had been purchased by the Viscount and Viscountess Charles and Marie-Laure de Noailles. This couple became Dali's first patrons. At the same time, they agreed to finance Buñuel's next movie. He telegraphed Dali at once and arrived in Figueras the day after the family estrangement. Together they immediately left for Cadaqués. After their recent Parisian successes — all the paintings from the Goemans exhibition had been sold for from six to twelve thousand francs, a high price for an unknown painter, and the showing of *Un Chien Andalou*

had caused a scandal in intellectual circles of the French capital — the two men dreamed of making a movie totally different from anything which had thus far been filmed; this dream became the movie *L'Age d'or*. Unfortunately each one of them had ideas which ran counter to those of the other. Indeed, Dali was hoping to be able to express in this film the violence of love filled with the splendors of the creation of all the Catholic myths. At this time he was already amazed and obsessed by the grandeur and the ostentation of Catholicism. He told Buñuel to imagine monstrances, a pile of bones, a council meeting of archbishops among the rocks — all this soaked with water from the apocalyptic and lunar coves of Cape Creus. But appearances notwithstanding, the anti-conformist ideas of Dali and Buñuel were radically different. Dali said that Buñuel with typical Aragonese stubbornness transformed the whole thing into nothing but anticlericalism. He himself knew that true sacrilege was infinitely more subtle and more refined than the use of simple blas-

phematory images. Buñuel went back to Paris with the scenario of *L'Age d'or* to do the cutting. He finished the film without Dali. It was first shown at Studio 28 in Paris on November 28, 1930, without anything happening, but at the December 3 showing a violent brawl broke out between the Royalists and the Surrealists, and subsequently the police banned the film.

Shortly after the departure of his friend, Dali received a letter from his father telling him in no uncertain terms that he was banished from the family. After having shaved his head, he climbed into the hills behind the family home to contemplate for the last time the town where he had spent his childhood. Then, placing on the roof of the waiting taxi the two canvases on which he was working, *The Invisible Man* and *Imperial Monument to the Child-Woman*, he left to take the train to Paris.

Dali's external appearance at this time would never have led one to suspect that he would become the best-known and the most famous contemporary painter of

23. THE PERSISTENCE OF MEMORY. 1931. Oil on canvas, 9½ × 13". *The Museum of Modern Art, New York*

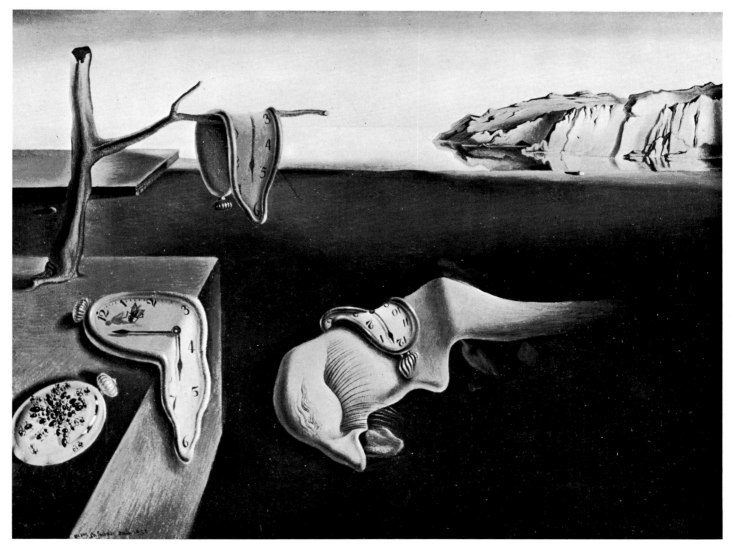

modern times, along with his compatriot Pablo Picasso. In his excellent book *Révolutionnaires sans révolution*, André Thirion sketches the following portrait: "In spite of his stay at the Academy of Fine Arts in Madrid, Dali gave the erroneous impression of having scarcely been cut off from his mother's apron strings. He wore a thin moustache like that of the movie star Adolphe Menjou. He was slender, timid, and phlegmatic but well-mannered. His inexhaustible eloquence was enhanced by the comic effects of his natural humor and Spanish accent, but he knew how to keep quiet and did so for long periods, curled up in an armchair, observant and serious. His prodigious intelligence enabled him to topple no matter what intellectual structure by bringing into play comical enormities at which he was the only one who did not laugh."

After arriving in Paris and again joining Gala, who had just left Paul Eluard, Dali immediately began to participate in the activities of the Surrealist group. He was seen at the Place Blanche on the terrace of the Café Cyrano, headquarters of the movement. His pictures, whose subjects clashed vigorously with the works of the other Surrealist painters of the time, were of unparalleled interest to Breton, Eluard, Aragon, Tzara. In fact, it was André Breton who wrote the preface to the catalogue of the first exhibition in the Goemans Gallery, saying about the paralyzing images depicted in the canvases, "Absolutely new and visibly mal-intentioned beings hereupon enter into play. It is with a sinister joy that we watch them pass by, unhindered, and realize, from the way in which they multiply and *swoop down*, that they are beings of prey." Sometimes Breton and his friends wondered if the miniature character of Dali's paintings allowed him in a sense to work on them for a long time, asking themselves if

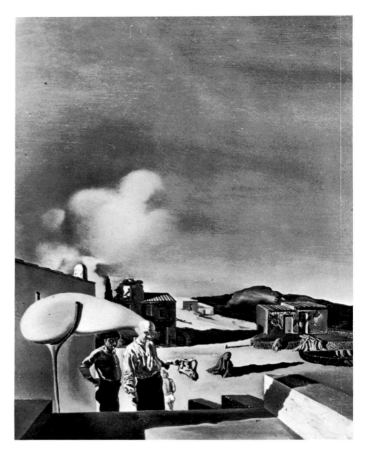

25. THE AVERAGE, FINE, AND INVISIBLE HARP. 1932. Oil on panel, 6¼ × 8⅛". *Private collection*

24. SIX APPARITIONS OF LENIN ON A PIANO. 1931. Oil on canvas, 44⅞ × 57½". *Musée National d'Art Moderne, Paris*

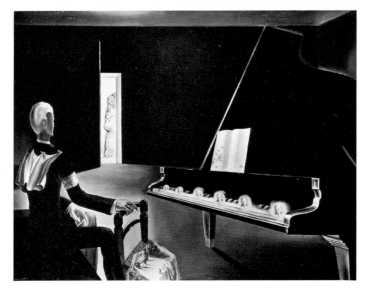

such works done in much larger formats would not have become veritable photographic depictions. They were wrong. The painter, indeed, had not waited for 1929 and his arrival in Paris to develop his method for the systemization of confusion, a method which made it necessary to hide or divulge in turn what was convenient for him as far as his painting, his disquisitions, and his life were concerned. Breton was not the only one to be mistaken. André Thirion acknowledged that less than two months after Dali's arrival in Paris they were to think otherwise: "What Dali brought to Surrealism was capital to the life of the group and for the development of his ideology. Those who wrote the contrary have borne false witness or have not understood anything at all. It is not true either that Dali ceased to be a great painter in the 1950s, although the manner in which he embraced Catholicism was heart-sickening enough. Like all artists, Dali has not consistently enjoyed the same privileges of inspiration. Certain of his commercial works are mediocre. While they are not always bad, they are never wholly inconsequential. One always discovers anew in spite of everything exemplary draftsmanship, a surprising strength of invention, and a sense of drama and humor. Surrealism owes much to his imagery."

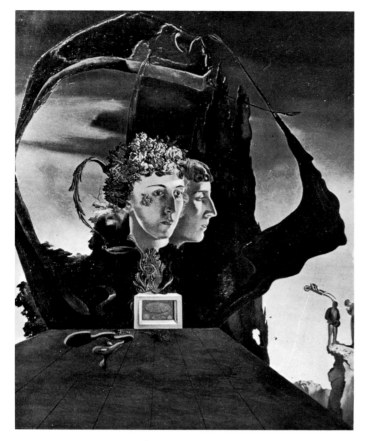

26. PORTRAIT OF THE VICOMTESSE MARIE-LAURE
DE NOAILLES. 1932. Oil on panel, 10⅝ × 9″.
Private collection

subjects have changed, due to general historical or personal necessities.

Dali withdrew from the ideology that surrounded Surrealism by means of his religious works. But only his Mediterranean materialism permits us to understand why he is so passionately devoted to a method of expression as new as holography, after having given, often before others, the signal in his paintings of such scientific advances as Bikini and the discoveries of modern physics, cybernetics, the space adventure, hibernation, or DNA and the nucleic acids, the source of genetic memory.

In 1931 Dali's imagery was not able to feed on conversations alone, on meetings or editing of treatises in which too often he saw the typical petit-bourgeois French mind manifesting itself. In brief, the activities of the Surrealist movement were insufficient to assuage his thirst for knowledge. Only one place in the world permitted the painter to assimilate the succulence contained in the discovery of ideas and beings: Catalonia, his native land. The phenomenon had already begun as early as 1921 while he was studying in Madrid. Besides, coming to Paris to conquer the city for him never meant living there permanently or becoming a Parisian. Just the contrary. Shortly after having again joined Gala, Dali and she left for Spain with the objective of buying a house in Cadaqués. The problem was not made any easier by the hostility of the notary father toward his son; the senior Dali did not like the idea of his son installing himself permanently

Few critics have realized that this imagery finds its source in exactitude of detail. In contrast to other Surrealist artists, such as Yves Tanguy or Max Ernst, in whose works the landscapes are totally imaginary, in all Dali's pictures these backgrounds are painted from the precise notations he has accumulated, systematically codified, and minutely carried in stock since childhood in a brain that Picasso compared to an outboard motor continuously running. If we view the situation from the point of view of André Malraux's *Imaginary Museum* with all the comparisons that this would entail, it is evident that Dali's work has known aesthetic curves of varying importance. On the other hand, if we look at things from the point of view of authenticity, vitality of the subject and of its contemporary reality at the moment of expression, Dali never experienced a crisis because he knew how to turn to his past the better to enjoy the present. His painting contains no prophetic ambition of the romantic type; it contents itself through his genius to reconstitute with clairvoyance images as exact as possible of each precise period lived through by the artist. He has never ceased to remain faithful to himself in his painting, as in his writing, with an almost insolent honesty. Only his

27. ATAVISM OF TWILIGHT. 1933–34. Oil on panel,
5⅝ × 6⅝″. *Kunstmuseum, Berne*

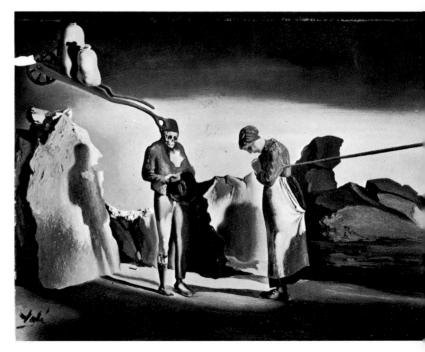

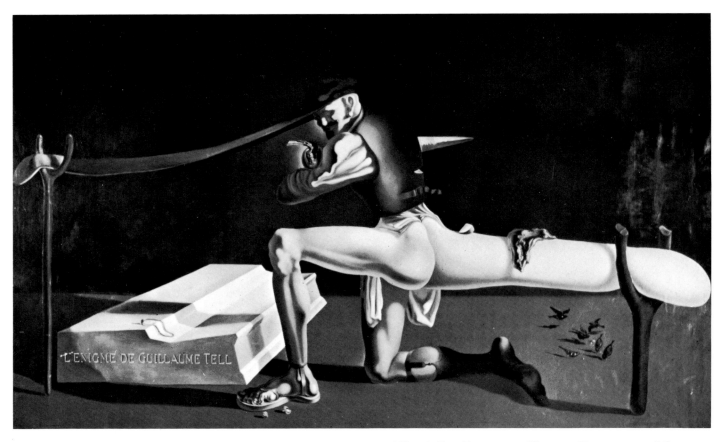

L'ENIGME DE GUILLAUME TELL

28. (*Above*) THE ENIGMA OF WILLIAM TELL. 1933. Oil on canvas, 78⅝ × 128″. *Moderna Museet, Stockholm*

29. (*Left*) MYSELF AT THE AGE OF TEN WHEN I WAS THE GRASSHOPPER CHILD. 1933. Oil on panel, 8⅝ × 6⅛″. *Collection Mr. and Mrs. A. Reynolds Morse, on loan to Salvador Dali Museum, St. Petersburg, Florida*

in the village where he himself resided periodically. With the money from the pictures purchased by the Viscount of Noailles, Dali and Gala bought a fisherman's barracks beside the tiny bay of Port Lligat about two kilometers from Cadaqués. Every year the couple returned to Port Lligat, where they stayed from spring to early autumn to inventory, measure, and digest what they collected during the winter. Dali's and Gala's migrations from Port Lligat to Paris and New York were prevented by only two events of the foremost importance: the Spanish Civil War and the Second World War.

The faithful transcription of dreams has always played a major role in Dali's work. The painter had studied psychoanalysis and the works of Freud before joining the Surrealists. To dream is easy for him because of his Mediterranean heritage. A siesta, to him, has always opened the doors of a pre-sleep period, the instant when one forgets the presence of one's body. Dali's demonology owes a great deal to his reveries. They have given birth to het-

30. THE SPECTER OF SEX APPEAL. 1934. Oil on panel, 6⅝ × 5⅛". *Fundación Gala-Salvador Dali, Figueras*

31. THE WEANING OF FURNITURE-NUTRITION. 1934. Oil on panel, 7 × 9½″. *Collection Mr. and Mrs. A Reynolds Morse, on loan to Salvador Dali Museum, St. Petersburg, Florida*

soft, what difference does it make! As long as they tell time accurately."

The precise image of ants in the sunshine. A leafless olive tree with its branches cut.

Last, the landscape. For the person who does not know the region where Dali lives, the violence of the color might seem excessive. It is nothing of the sort. On the contrary, this vivid color renders exactly the effect of the light in the sky, on the sea, the seashore, and the rocks. The latter cannot be specifically located; they are the generalization of all the landscapes Dali had seen and painted before. His great merit is to have succeeded in synthesizing the ideal coast by use of familiar rocks and coves, thus giving the spectator the illusion of having seen them before.

Dali's output from 1930 to 1934 is particularly indicative of the method he used to systematize his obsessions. He called this system the "paranoiac-critical method" and gave the following explanation of it: "Paranoiac-critical activity: spontaneous method of irrational knowledge based on the critical and systematic objectivity of

erogeneous elements which he then brings together in his paintings without always knowing why. In the works of the Surrealist period, Dali treated those elements of disparate appearance with absolute realism which emphasized the proper character of each one of them, making an exact copy from a document, a photograph, or the actual object, as well as using collage. He increased the effect produced even more through the use of techniques stemming from the precision of Vermeer to the blurred shapes of Carrière. Once he had given an emotional autonomy to his protagonists he established communication between them by depicting them in space — most often in a landscape — thus creating unity in the canvas by the juxtaposition of objects bearing no relation in an environment where they did not belong. This spatial obsession derives from the atmosphere of Cadaqués, where the light, due to the color of the sky and of the sea, seems to suspend the course of time and allows the mind through the eye to glide more easily from one point to another. The famous painting in The Museum of Modern Art in New York, *The Persistence of Memory (The Soft Watches;* fig. 23), is an excellent example of the foregoing and contains the following elements:

The soft head in the center is born of reveries. At Cape Creus, Dali had seen a rock whose shape was very similar to this head.

The watches, which he says are "nothing more than the soft, extravagant, solitary, paranoiac-critical Camembert cheese of space and time," or again: "hard or

32. THE GHOST OF VERMEER OF DELFT, WHICH CAN BE USED AS A TABLE. 1934. Oil on panel, 7 × 5½″. *Collection Mr. and Mrs. A. Reynolds Morse, on loan to Salvador Dali Museum, St. Petersburg, Florida*

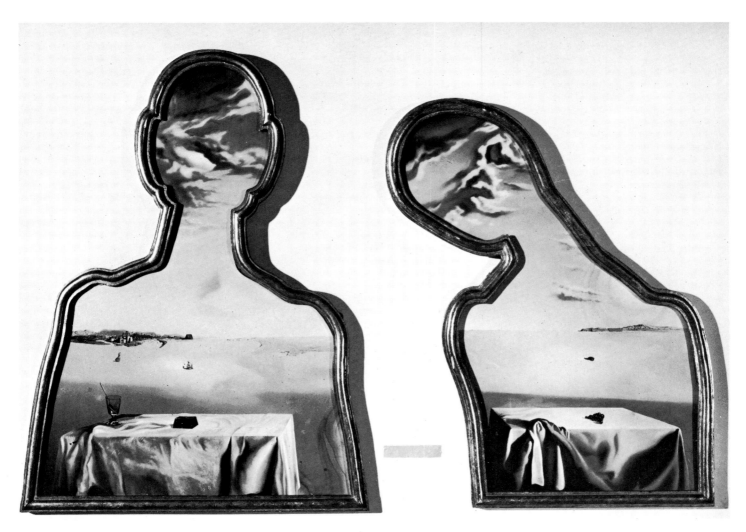

33. COUPLE WITH THEIR HEADS FULL OF CLOUDS. 1936. Oil on panel;
man, 36⅜ × 27¼" ; woman, 32⅛ × 24⅝". *Collection unknown*

the associations and interpretations of delirious phenomena." Breton was smart enough to pay homage to this discovery because he realized that Dali had just endowed "Surrealism with an instrument of primary importance, in particular the paranoiac-critical method, which has immediately shown itself capable of being applied equally to painting, poetry, the cinema, the construction of typical Surrealist objects, fashion, sculpture, the history of art, and even, if necessary, all manner of exegesis."

Let us name the principal obsessive themes being used at that time in Dali's pictures: William Tell, Lenin, anthropomorphic landscapes and figures, Millet's *Angelus*, Vermeer painting, and Hitler. Dali had momentarily abandoned his attempts at representing double images, begun in *The Invisible Man*, only to take them up again in 1935. The vast spaces leading off toward the horizon in his paintings have often been compared with those of De Chirico or Tanguy. The comparison is reasonable — and

Dali has never denied having seen the works of these artists before 1929 — but the manner in which he collects his material and the use he makes of it take away all interest in such a comparison. With Dali the infinite perspectives are of two types: the first, for example in the *Portrait of the Vicomtesse Marie-Laure de Noailles* (fig. 26), is from an entirely subjective source and is the result of pictures painted during the years 1926-28, with their arithmetical and geometrical studies, such as *Apparatus and Hand* (fig. 16) or *Inaugural Gooseflesh* (colorplate 10). The second translates impressions of places around Cadaqués, the Bay of Rosas, or the plain of Ampurdán near Figueras, which he had stored in his memory: *Myself at the Age of Ten When I Was the Grasshopper Child* (fig. 29), and *The Average, Fine, and Invisible Harp* (fig. 25), where Gala, half nude and seen from the back, is depicted with two fishermen in an exact copy of the landscape at Port Lligat, just as one sees it when coming out of their house; *The Specter of Sex Appeal* (fig. 30), in which

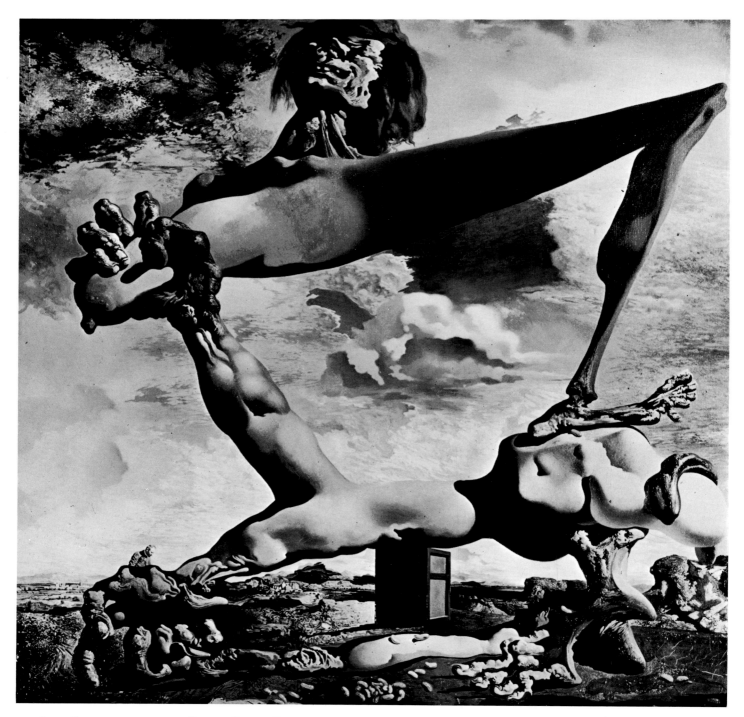

34. SOFT CONSTRUCTION WITH BOILED BEANS: PREMONITION OF CIVIL WAR. 1936. Oil on canvas, 39¼ × 39″. *Philadelphia Museum of Art. Collection Louise and Walter Arensberg*

Dali painted himself at the age of six, in an actual cove on the coast, contemplating the agonizing figure of the eternal woman, fruit of his childhood days spent on the beach where buxom Catalonian girls were bathing, and unconsciously recalled. The celebrated painting entitled *The Weaning of Furniture-Nutrition* (fig. 31) shows the painter's nurse sitting on the sandy shore at Port Lligat, and *The Ghost of Vermeer of Delft, Which Can Be Used As a Table* (fig. 32) uses a bend in the road which links Port

Lligat to Cadaqués as the spot for the apparition. *Enigmatic Elements in the Landscape* (colorplate 17) assembles the characters from the preceding pictures and places them on the plain of Ampurdán.

Dali's participation and his position in the Surrealist revolution can be summed up with the help of a few extracts from a list of contradictions written by him and published in his *Secret Life* under the title of "My Battle."

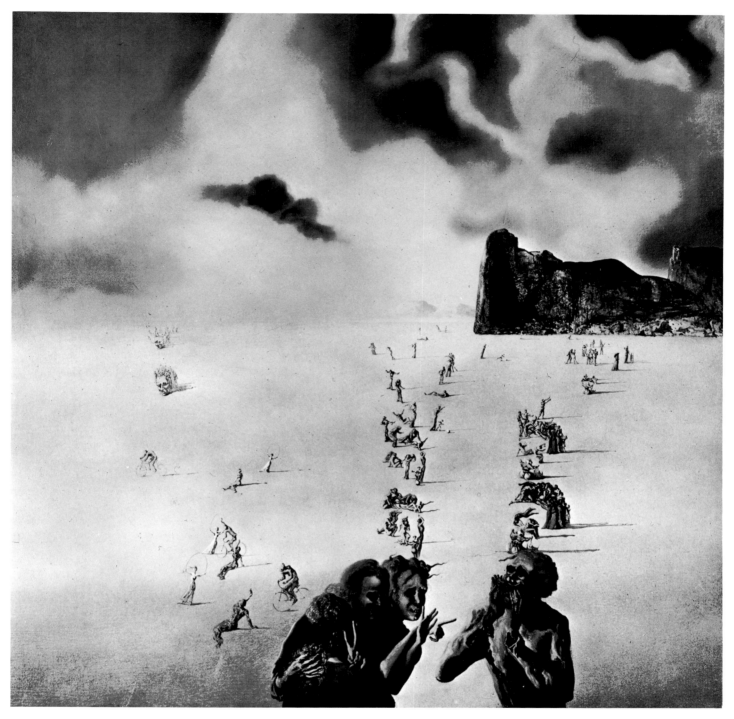

35. PERSPECTIVES. 1939. Oil on canvas, 25⅝ × 25¾". *Kunstmuseum, Basel. Emmanuel Hoffmann Foundation*

Against:	*For:*	*Against:*	*For:*
simplicity	complexity	Rembrandt	Vermeer
egalitarianism	hierarchization	savage objects	ultra-civilized 1900 objects
politics	metaphysics	medicine	magic
nature	aesthetics	philosophy	religion
mechanism	dreams	mountains	coast line
youth	maturity	phantoms	specters
spinach	snails	women	Gala
Buddha	the Marquis de Sade	men	myself
the sun	the moon	scepticism	faith

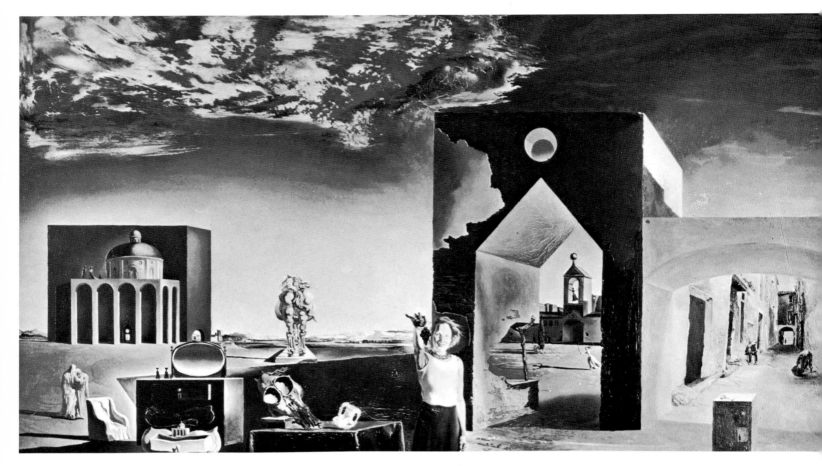

36. SUBURBS OF THE PARANOIAC-CRITICAL TOWN: AFTERNOON ON THE OUTSKIRTS OF EUROPEAN HISTORY. 1936.
Oil on panel, 18 × 26". *Private collection*

In addition to his writings—several books, among which are *La Femme visible, L'Amour et la mémoire*, and *Conquest of the Irrational*, and his articles for publications such as *Le Surréalisme au service de la révolution* and *Minotaure*—his most outstanding activity was the creation, with the sculptor Alberto Giacometti, of Surrealist objects functioning symbolically, for which he gave this explanation in a 1931 article: "These objects which lend themselves to the minimum of mechanical functions are based on phantasms and representations capable of being aroused by the accomplishment of unconscious acts." The first qualification of a Surrealist object was absolute unity, just as much from a practical point of view as from a rational one. Dali's wish was to create objects of a delirious and greatly obsessive character in which all the components would be concrete.

However, the political involvements of the Surrealists did not concern Dali, for whom "politics are merely historical anecdotes"; when he extolled the study of Hitler's character as a typical Surrealist phenomenon he irritated the group. Imperturbable, he continued nevertheless to treat his subject with the rigor of a scientific scholar, declaring: "The swastika, as old as the Chinese sun, de-

mands honor for the object itself. Nothing further may be done with a Surrealist object whose function has been unshakably decided…the Surrealist object is impractical, it has no purpose but to make man go ahead toward the outside and to cretinize him; the Surrealist object is made for honor, it exists only for the honor of the thought it contains."

In 1932, serious political divergences of opinion separated Louis Aragon and André Breton, but neither of them saw the infernal machine with which Dali had endowed Surrealism. "He was nothing but an intruder," André Thirion recounts; "not a Marxist and did not give a damn about it, impossible to make him enter into proletarian art. Since Aragon had lost all sense of humor, he found nothing funny about the whims of Dali." The artist had written a text, "Reverie," published in the fourth number of *Le Surréalisme au service de la révolution*, in which he related with total honesty and force the details of his erotic and imaginary adventure with a young girl of twelve called Dulita. This story of the tender young child became known as the Dulita Affair and caused a great to-do at *L'Humanité*, the communist newspaper. The text was judged pornographic; Aragon and some other Surre-

alists had to account for it before the control commission of the Communist Party. This aroused Breton's anger and only served to widen the gap which separated him from Aragon.

Two years later, Dali's obsessions with the image of Hitler—he had painted a "Hitlerian nurse" in one of his pictures—became so exasperating that it was decided to demand an explanation of him. During the course of the month of January 1934, the group summoned the painter to a meeting in the studio of Breton. Dali arrived wearing several sweaters and a muffler-scarf, supposedly suffering from the flu. During Breton's indictment he remained silent, keeping a thermometer in his mouth with which he contentedly checked his temperature from time to time. Then, preparing for the counterattack, he started to take off his wool sweaters one after another. During this striptease, he read the pleading he had prepared for his defense in which he said that, since he was trying to describe dreams, he did not have the right to

exercise any conscious control over their content. Was it his fault if he dreamed of Hitler or of Millet's *Angelus?* When Dali came to the passage where he said, "Therefore, according to me, Hitler has four balls and six fore-skins," Breton shouted vehemently, "How much longer are you going to continue to bore us with this damn nonsense about your Hitler?" And Dali replied in the midst of general hilarity, "All night long I dream of sodomizing you, consequently I have the right to paint my dream." Following this unforgettable meeting, he was notified of his expulsion from the group. He has given this explanation of his eviction in his *Le Journal d'un génie:* "I took Surrealism literally, neglecting neither the blood nor the excrements on which its advocates fed their diatribes. In the same way that I had applied myself to becoming a perfect atheist by reading my father's books, I was such a conscientious student of Surrealism that I rapidly became the only 'integral surrealist.' To such a degree that I was finally expelled from the group because I was too

37. METAMORPHOSIS OF NARCISSUS. 1936–37. Oil on canvas, 20 × 30". *Tate Gallery, London*

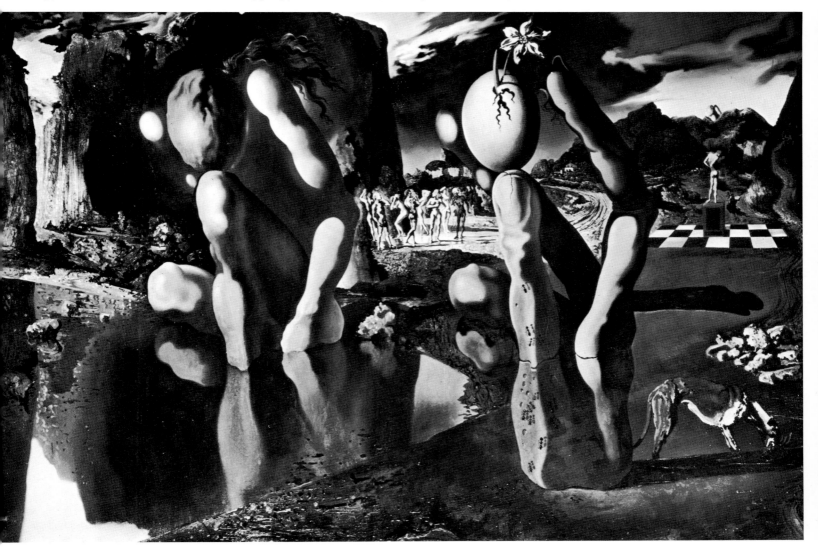

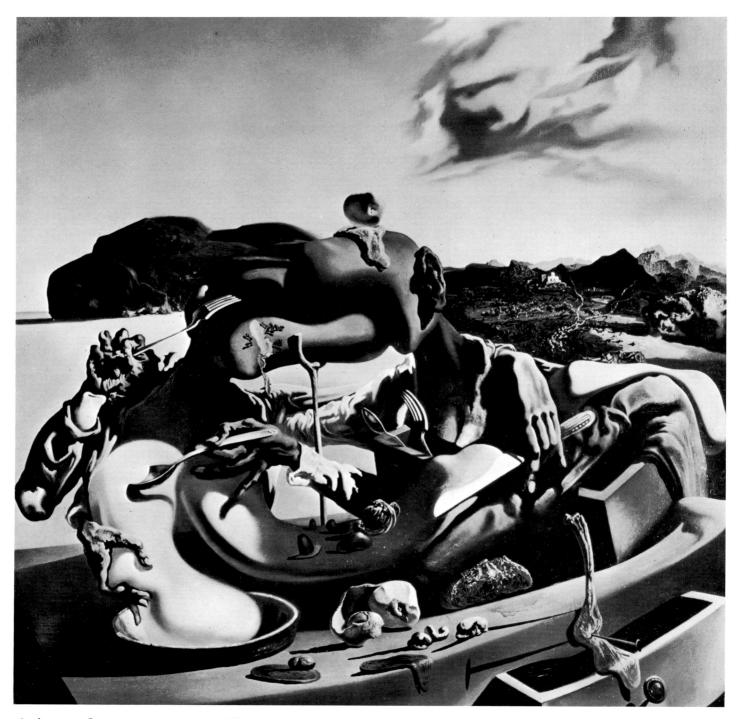

38. Autumn Cannibalism. 1936–37. Oil on canvas, 31½ × 31½". *Tate Gallery, London*

Surrealist. The alleged reasons for this I considered to be of the same nature as those which had prompted my expulsion from my family. Gala-Gradiva, 'she who advances,' 'the Immaculate intuition,' had been right once again." Nevertheless, the movement needed a brilliant publicity agent like Dali, and Breton knew it, so Dali continued to collaborate with it at the exhibitions: in London in 1936 where he gave a lecture dressed in a deep-sea diver's suit in which he nearly suffocated to death, and in Paris at the Beaux-Arts Gallery in January

and February 1938, "the visitor received his first shock in the lobby," Marcel Jean relates in his *History of Surrealist Painting*, "where Salvador Dali was showing his *Rainy Taxi*, an old rattletrap inside which an ingenious system of tubing produced a violent downpour that soaked two mannequins, one, with a shark's head, in the driver's seat, the other, a bedraggled blonde in evening dress, seated in the rear among heads of lettuce and chicory over which enormous Burgundy snails were drawing their slimy trails, exhilarated by the deluge."

As soon as he arrived in Paris, Dali made his way into the worldly circles of the capital and became an habitué of the drawing rooms where Surrealism was in vogue. At the end of 1933, the dealer Julien Levy exhibited for the first time in New York twenty-five paintings by the Catalonian artist, who was already burning with desire to visit America. He had to cross the Atlantic whatever the cost to see with his own eyes this New World which was so much more receptive to contemporary painting than Paris, where the French museums continued to ignore the existence of Picasso. A rich American lady, Caresse Crosby, urged him to make the trip, promising the support of her relatives and assuring him of favorable results as a painter. Picasso advanced the couple the money necessary to pay the price of their passage on the steamship *Champlain*. In New York, "that immense gothic Roquefort cheese of verdigris and dirty white," the second exhibition at the Julien Levy Gallery was an acknowledged success; nearly all the canvases found buyers. Dali understood, after his first sojourn in the United States, that the key to his fame and fortune lay in New York and America, where he would have to return periodically.

During the years preceding the Second World War, he therefore applied all his energy to making himself well known. It was then that his painting began to be appreciated. He was lucky enough to have an English patron of the arts, Edward F. W. James, godson of King Edward VII, become interested in his work. This gentleman proposed to buy all his output. The agreement lasted about two years, 1935-36. Today the James collection—from which there are several important works in the Tate Gallery in London (*Metamorphosis of Narcissus* [fig. 37] and *Autumn Cannibalism* [fig. 38]) and in the Boymans-van

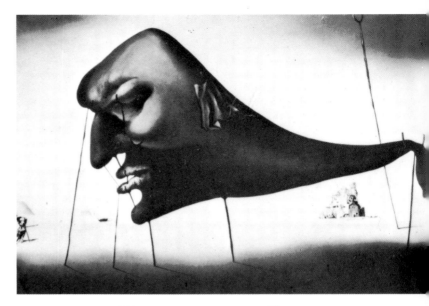

40. SLEEP. 1937. Oil on canvas, 19⅝ × 30¼".
Private collection

Beuningen Museum in Rotterdam (*Medianimic-Paranoiac Image*)—remains the first and best collection of Dali paintings and drawings assembled by a connoisseur before the Second World War.

In 1936 the Civil War was rampant in Spain, and Dali and Gala had to give up their sojourns in Port Lligat. They traveled throughout Europe and more particularly in Italy, where they lived. The influence of the masters of the Renaissance, seen in the museums of Florence and Rome, is recognizable in the groups of figures used at the time by the artist to create double images in his pictures,

39. BEACH SCENE WITH TELEPHONE. 1938.
Oil on canvas, 29 × 36⅛". *Tate Gallery, London*

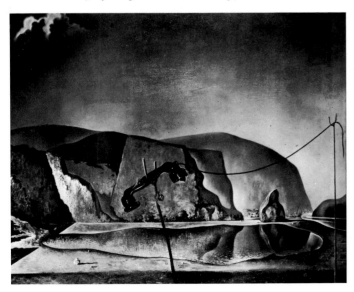

41. THE SUBLIME MOMENT. 1938. Oil on canvas,
14⅝ × 18⅛". *Staatsgalerie, Stuttgart*

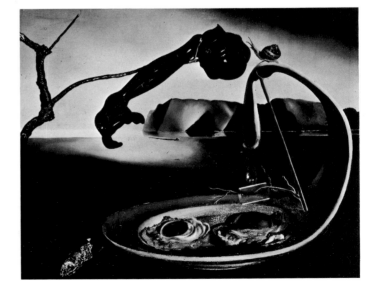

42. SENTIMENTAL COLLOQUY (Study for a Ballet). 1944. Oil on canvas, 10⅝ × 16⅛".
Collection Mr. and Mrs. A. Reynolds Morse, on loan to Salvador Dali Museum, St. Petersburg, Florida

such as *Spain* (colorplate 21). During the years preceding the war the painter had paid a visit to Sigmund Freud in London and had spent some time painting at the estate of Coco Chanel on the Côte d'Azur. In New York, at the beginning of 1939, he accidentally broke the plate-glass window at Bonwit Teller's, a luxurious department store on Fifth Avenue, because, without his permission, the window display he had designed and arranged had been changed. Before leaving New York, he published his manifesto, *Declaration of the Independence of the Imagination and the Rights of Man to His Own Madness.*

When the Second World War broke out, Dali, Gala, and Marcel Duchamp left Paris for Arcachon. A few days before the German invasion, the couple left for Spain and Portugal. Dali made a detour to Figueras and Port Lligat to visit his family and to see the condition of his house after the Civil War. Then he joined Gala in Lisbon, where they embarked on the *Excambion* to go to New York.

After arriving in the United States they settled in Virginia at Hampton Manor, the estate of their friend Caresse Crosby, where they frequently returned afterwards. It was there that Dali completed his excellent autobiography begun in Arcachon, *The Secret Life of Salvador Dali.* Caresse Crosby has related how, having had to go away for a few weeks, she left Hampton Manor,

where the writer Henry Miller was also a guest along with the Dalis. Imagine her surprise upon returning to find the painter busy writing his memoirs and Henry Miller doing watercolors! During the eight years that their American sojourn lasted, Dali and Gala lived in New York and in California, near Monterey, south of San Francisco. Dali even had a studio in a villa at Pebble Beach — he who, outside of Port Lligat, had painted most of his pictures in hotel rooms with the canvas placed on a chair.

November 19, 1941, was the opening of the first retrospective exhibition of Dali's works, at The Museum of Modern Art in New York: forty-three paintings and seventeen drawings selected and well assembled by James Thrall Soby. From February 1942 to May 1943, the same exhibition was shown in eight of the largest cities in the United States, thus assuring Dali's notoriety. The American vitality was to him the choicest of foods. Commercial propositions began to become more numerous. Without accepting them all, he did not always refuse them, because he realized that by means of all these side activities he would be able to recognize and capitalize on the possibilities of a country in which he must live in exile. Dali started to earn a lot of money, to such a point that Breton made a cruel anagram of his name — but

"auspicious" says Dali: Salvador Dali = Avida Dollars. In the paintings of the American period, the color, the open spaces, and often the landscape are taken from memories of Catalonia; but, living in America, Dali sought many of his subjects and characters there. Long before other artists, he had the audacity to paint a Coca-Cola bottle, point his finger at the race problem, and depict the passion of the American people for football — bringing all that together in the same canvas, *The Poetry of America* (colorplate 28). At the same time, Dali was painting numerous portraits; he also designed a few murals for homes, among which were the panels he did for the apartment of the Princess Gourielli, better known as Helena Rubinstein. He collaborated regularly with fashion magazines such as *Vogue, Harper's Bazaar,* and *Town & Country* and created the scenery and costumes for several ballets, *Labyrinth* in 1941, *El Café de Chinitas* of Lorca, *Sentimental Colloquy,* and *Bacchanale* in 1944.

During the latter year, in a few weeks, he wrote his first novel, *Hidden Faces,* at the home of the Marquis of Cuevas in New Hampshire. In 1941 Dali had announced his desire to return to classicism in his painting, and that he hoped to find faith, affirming that, if he had participated with the fanaticism of a Spaniard in all speculative investigations, he had never had the will to reject tradition or religion or to belong to any political party. He concluded his autobiography in this manner: "And what is heaven? Where is it to be found? Heaven is to be found neither above nor below, neither to the right nor to the left, heaven is to be found exactly in the center of the bosom of the man who has faith!" He applied this desire to return to classicism from 1945 on by simplifying the subject matter of his pictures in order to concentrate on painting them better. The most remarkable work of this series is without a doubt the superb portrait he did of Gala, *Galarina* (colorplate 31). Although he continued

43. ATOMICA MELANCHOLICA. 1945. Oil on canvas, 25⅝ × 33½". *Private collection*

39

44. RAPHAELESQUE HEAD EXPLODING. 1951. Oil on canvas, 17½ × 13¾". *Private collection*

his habit of working in several directions at the same time, he nevertheless did not lose contact with what was taking place around him and he showed an enthusiastic interest in the fascinating progress being made in scientific fields, especially in nuclear physics. Consequently, he painted the atomic mushroom in certain of his pictures, *Atomica Melancholica* (fig. 43) or *The Three Sphinxes of Bikini*. However, it was not until 1949, a year after he returned to Europe, that he began his first great religious work: *The Madonna of Port Lligat* (colorplate 34).

Dali did not return to Paris immediately after the war; he was too busy preparing for the transmutation of the psychoanalytical Dali into the nuclear-physical Dali. Mysticism must remain in touch with the concrete or risk becoming a game. The only way in which to impregnate his work with mysticism was to make his painting even more objective. It was then that he wrote a treatise on the technique of painting, *Fifty Secrets of Magic Craftsmanship*, of which he says half-ironically, half-seriously, "It was while reading it that I really learned to paint almost as well as Zurbarán." In most of the pictures of this period the composition is based on rigorous mathematical disciplines; *Leda Atomica* or *Giant Flying Demi-Tasse with Incomprehensible Appendage Five Meters Long* (colorplate 29) are entirely but invisibly built upon the rules of the divine proportions as set forth by the Italian monk Fra Luca Pacioli and upon the research on the Golden Number done by the Rumanian mathematician Prince Matila Ghyka. Dali has explained that through his research he was involuntarily preparing himself for the discovery of the morphology of the birth of his corpuscular and rhinoceratic painting, for he says, "The obsessive outline of the liturgical crouton is the forerunner of my almost divine and chaste rhinoceros-horn period. At this point, I decided to sublimate all the revolutionary experiments of my adolescence in the great mystical and realistic tradition of Spain." When he returned to his country, after finishing *The Madonna of Port Lligat* in 1950 (colorplate 34) and *Christ of Saint John of the Cross* in 1951 (colorplate 35) he began work in 1952 on his first corpuscular canvases and finished 102 watercolors to illustrate Dante's *Divine Comedy*. The preceding year he had published *Mystic Manifest* and a few announcements pertaining to his nuclear-mystic art and the way in which he had arrived at it. "They thought I was skillful with brushes, but proof will come, because I have voluntarily forced myself often through pure ethics to do super chromo-lithography which has frequently looked more pictorial than with most other painters who are exclusively preoccupied with painting. I am about to execute a divisionistic, rhinocerotic, anti-protonic painting in order to transmit the great cosmogonic news of our epoch." The discontinuity of matter, the nuclear-mystic, Dali's desire to return to mysticism were taken seriously by only a few people; Father Bruno, editor-in chief of *Carmelite Studies*, wrote about Dali and the angelic world: "In a tape-recorded conversation in 1956 made with his consent, Salvador Dali told me that nothing stimulated him more than the idea of an angel. Dali wanted to paint heaven, to penetrate the celestial vaults in order to communicate with God. God is an elusive idea for him, impossible to make concrete. Dali thinks that perhaps it might be that substance for which they are searching in nuclear physics. For him God is not, however, cosmic; that would imply, he told me, a limitation. He sees it as a series of contradictory ideas which cannot be resolved into any structural ideal. Dali, being essentially Catalonian, needs to touch forms; *now that is true of angels.*

While very young, he told me, he created a picture about angels, and if he has turned for some time toward the Assumption of the Virgin, it is, he declares, because she rose into heaven through *the sheer strength of the angels.* And Dali would like to know the secret of this elevation...."

Dali imagines that protons and neutrons are *angelic elements* because in the celestial bodies, he explains, "there are residues of substances; it is for this reason that certain beings appear to me *so close to angels* such as Raphael and Saint John of the Cross. Raphael's temperature is like that almost chilly air of spring, which in turn is exactly that of the Virgin and of the rose." And he adds solemnly, "I need an ideal of hyperaesthetic purity. More and more I am preoccupied by the idea of chastity. For me, it is an essential condition of the spiritual life."

Such works as *Raphaelesque Head Exploding* (fig. 44), *Galatea of the Spheres* (fig. 45), *Assompta Corpuscularia Lapislazulina, Rhinocerotic Figure of Phidias' Illisos* (colorplate 36), or *Paranoiac-Critical Study of Vermeer's Lacemaker* (fig. 85) are fine illustrations of the Catalonian painter's work of this period.

The elements that appear contradictory in Dali's paintings have already been mentioned several times. It has been my pleasure to follow the development of the painter's obsessions from 1954 to 1960, when, for our own extreme and very serious amusement, we made a film together: *The Prodigious Story of the Lacemaker and the Rhinoceros.* Placing together in a single title Vermeer's *Lacemaker* and a rhinoceros seemed at first sight completely extraordinary. Here is the explanation of it. From his very first youthful paintings, Dali has always attached an extreme importance to the composition of his pictures; so, following his work with Matila Ghyka, he became very enthusiastic about the dynamics of the logarithmic spiral which mathematically regenerates itself, and at the same time he studied the recent developments in nuclear physics and was fascinated by the new particles of matter. At an early age he had developed a passion for Vermeer and the quality of his painting; therefore, in 1954, his attention focused, in a typical paranoiac-critical fashion, on the work of the painter of Delft called *The Lacemaker,* a reproduction of which was ever before his eyes in his parents' home. Beneath her calm appearance, the lacemaker represented for him the greatest violence and the most colossal cosmic synthesis because of the rigor of the construction and the corpuscular aspect of the minute brushstrokes with which Vermeer had painted his picture. Dali decided to give a lecture in which he would expound upon the connections between this lacemaker and a rhinoceros; given in the large amphitheater of the Sorbonne under the ceilings painted by Puvis de Chavannes, it is today known to all who are interested in the mechanism of Dalinian thought. The

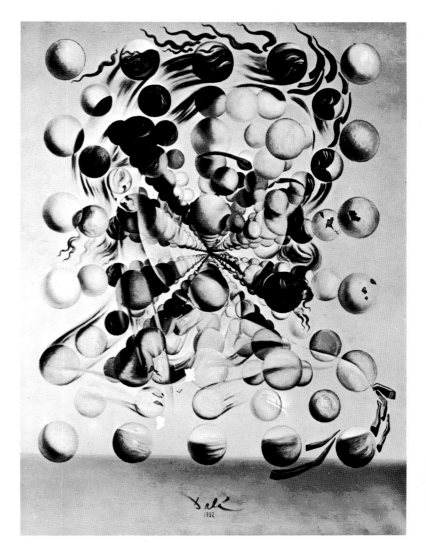

45. GALATEA OF THE SPHERES. 1952. Oil on canvas, 25⅝ × 21⅛". *Fundación Gala-Salvador-Dali, Figueras*

painter has always understood how to win his public with the first word he says. The beginning of this lecture, given on December 17, 1955, and entitled "Phenomenological Aspects of the Paranoiac-Critical Method," is worth repeating here: "Salvador Dali has decided to make the most delirious announcement of his life in Paris, because France is the most intelligent country in the world, France is the most rational country in the world; on the contrary, I, myself, come from Spain, which is the most irrational country in the world and also the most mystical. Intelligence leads and brings us to the foggy nuances of scepticism, intelligence guides us to the gastronomic coefficient of super-gelatinous, Proustian, and gamy uncertainty. It is for this reason that it is good and necessary that from time to time Spaniards like Picasso and myself come to Paris to dazzle you...by showing you a raw and bleeding piece of truth." In the rest of

Every year from 1950 to 1970, over a period of twenty years, Dali has produced a canvas of museum dimensions; all these works are now in museums or important private collections. Among them are the following: *Crucifixion (Corpus Hypercubus)* (colorplate 37), Metropolitan Museum, New York; *The Last Supper*, National Gallery, Washington, D.C.; *Santiago el Grande*, Beaverbrook Art Gallery, New Brunswick, Canada; *The Discovery of America by Christopher Columbus* (colorplate 38), The Salvador Dali Museum, St. Petersburg; *The Battle of Tetuán* (fig. 51), formerly in the Huntington Hartford Collection; *Galacidalacidesoxiribonucleicacid*, New England Merchants National Bank, Boston; *The Apotheosis of the Dollar; The Perpignan Railway Station; Tuna-Fishing*, Paul Ricard Foundation; and *The Hallucinogenic Toreador* (colorplate 39), The Salvador Dali Museum, St. Petersburg. Since the first retrospective exhibition at The Museum of Modern Art in New York in 1941, many major exhibitions have shown the works of Dali to the world. The first one took place in Japan during the Olympic Games of 1964, shortly after the Venus de Milo was exhibited in that country. This show was opened by

47. Model posing in Dali's studio in Cadaqués

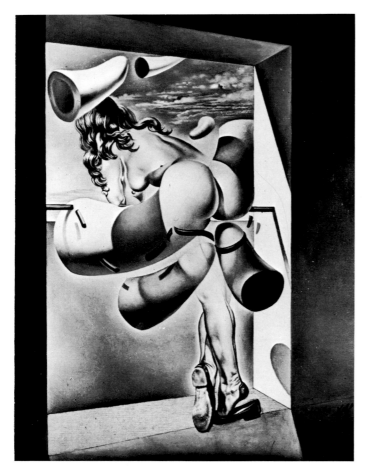

46. Young Virgin Auto-Sodomized by Her Own Chastity. 1954. Oil on canvas, 16 × 12".
Collection Hugh Hefner, Playboy Enterprises, Los Angeles

his paper, he said that the curve of the horn of the rhinoceros was the only one which was a perfect logarithmic spiral and afterwards explained his paranoiac-critical copy of Vermeer's painting, in which one sees *The Lacemaker* represented by an infinite number of rhinocerotic horns. Speaking of the pachyderm, whose hindquarters were being shown on a screen, he said, provoking general hilarity, "I have analyzed this part of the rhinoceros with the result that it exactly resembles a layered sunflower. Therefore, the rhinoceros is not satisfied with carrying one of the most beautiful logarithmic curves on the end of his nose, but, besides, on his rear end he has a kind of galaxy of logarithmic curves in the form of a sunflower," thus establishing the following continuity: nebula = *The Lacemaker* = rhinoceros horn = corpuscular and logarithmic arrangement of the sunflower seeds, then of the cauliflowerets = the granulations of the sea urchin, which would be, according to Dali, a drop of water bristling with gooseflesh at the very moment of creation caused by the fear of losing the purity of its original form!

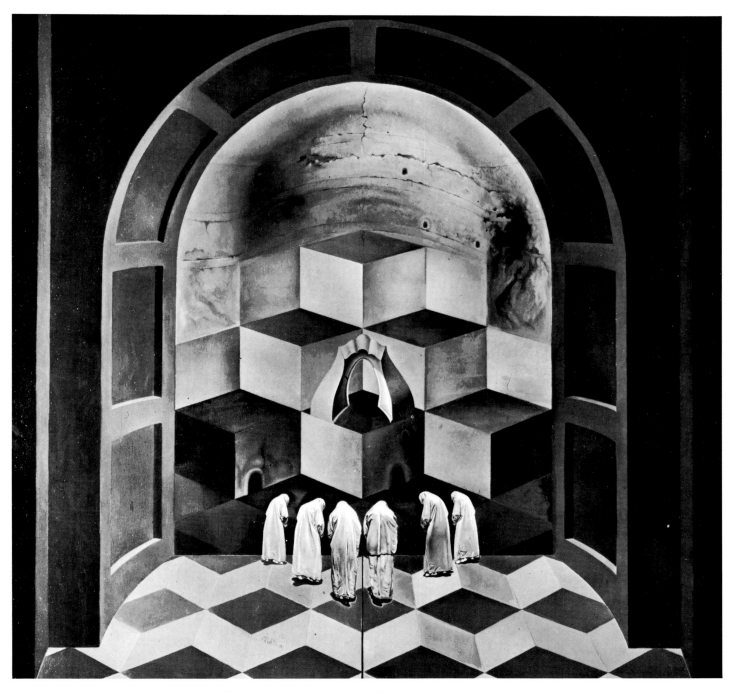

48. THE SKULL OF ZURBARÁN. 1956. Oil on canvas, 39¼ × 39¼".
Hirshhorn Museum and Sculpture Garden, Smithsonian Institution, Washington, D.C.

the Emperor's brother, Prince Takamatsu. The following one, in New York, in 1965-66 at the Gallery of Modern Art, brought together 366 of Dali's best paintings and drawings, of which the largest number came from the collection of Mr. and Mrs. A. Reynolds Morse and which, since 1982, have been in The Salvador Dali Museum in St. Petersburg. In 1970, the Boymans-van Beuningen Museum in Rotterdam assembled the first important retrospective exhibition in Europe, showing the masterpieces from the Edward James collection,

among which were certain ones that Dali himself had not seen since the day he painted them — such as *Medianimic-Paranoiac Image*, *Geological Justice* (colorplate 18), and *Sun Table* (colorplate 19). The success of this last show surpassed all the hopes of those who organized it as much as it surprised them. Indeed, the public that came to the Boymans-van Beuningen Museum was made up not only of art lovers, but also of a vast number of young people looking for oneiric images in the living and real universe of their own lives.

49. METAMORPHOSIS OF HITLER'S FACE INTO A LANDSCAPE IN THE MOONLIGHT TO THE ACCOMPANIMENT
OF TOSELLI'S SERENADE. 1958. Oil on canvas, 10 × 12¼". *Private collection*

In addition to his painting, Dali has never ceased making drawings and watercolors. On the other hand, about 1934, shortly after having illustrated *Les Chants de Maldoror*, he almost completely abandoned etching — a technique of which he was a past master thanks to his early education in this medium by Juan Núñez, his professor in Figueras, a prizewinning etcher — but returned to it about 1958. From 1964 on, his notoriety and the exigencies of the art market — which had vastly developed during this period — forced Dali into taking up the stylus again. Since then, he has treated many subjects with great imagination, and especially with an energy at the least bewildering, leaving certain connoisseurs non-

50. HYPERXIOLOGICAL SKY.
1958–60. Oil on canvas with inlaid nails and teeth,
12¼ × 17". *Private collection*

plussed and irritated. For these people, art remains linked to the bourgeois notion of works more or less unique, and, because they have invested their money in art, they expect the successful artist who has passed the age of sixty to be reasonable and reassuring. So Dali, that director landscapist of things out of their element, continues to upset those who wish to see him return to the bosom of Art with true value, not only by his strange behavior but also by the apparent inequality in his output. For a long time, collectors and dealers have reproached Dali for selling his pictures at a much higher price than that offered for the same works in auctions. Why shouldn't he have done it, when, during all his life, with Gala's efficacious help but without the support of a network of galleries to uphold his prices, he has been able to find art lovers ready to pay dearly to own his paintings? Certain of Dali's works of the Surrealist period have tripled in price in just a few years, making him the highest priced of all the painters of this movement. Imperturbable, the exhibitionist Dali continues to feed the news media with his famous moustaches, his canes, his court, and his remarks, of which the exact sense and implications remain incomprehensible most of the time. During the Surrealist epoch he did a lot of talking but also knew how to remain silent for a long time. Now he has had to transform the rhythm of his life in order to protect the creative side. The long weeks at the end of autumn passed at Gala's side, alone in Port Lligat, are over. His position is such that it would allow him to retire behind high walls as Picasso did. But Dali is not a hermit; besides, he has found a better solution, and one which fits the situation perfectly: to add to the motor of his brain an "overdrive," which he keeps running twenty-four hours out of twenty-four. To feed this motor, working at full speed night and day, an exceptional fuel is necessary. Dali continuously supervises the air-gasoline

51. The Battle of Tetuán. 1961–62. Oil on canvas, 121 × 160". *Private collection*

mixture which goes into the tank and regulates their proportions himself. The components of this mixture are the artistic, scientific, economic, social, and historical phenomena of the era. The product which is obtained is not always refined, but the machine itself is so well made that it automatically rejects the things that are useless.

After the period that was influenced by the discoveries of nuclear physics, Dali, expanding the field of his curiosity, became interested in the most recent scientific research, going from that of Crick and Watson on deoxyribonucleic acid — the key to life — to the latest discovery of the Nobel Prize winner Dennis Gabor, holo-

graphy, and on through the experiments with hibernation in order to defeat death. In art, he has observed all the trends after Surrealism with the liveliest of interest, even those which had nothing to do with his own painting, such as Op Art. They range from tachisme to American hyperrealism, and include Pop Art, Jackson Pollock to Malcolm Morley, along with Mathieu, de Kooning, and Andy Warhol.

The images and the ideas conceived by the brain of such a genius do not lend themselves to classification by the art-tired critic! Their organized confusion obliges him to observe a prudent silence, thus permitting the

painter of Figueras to escape the bureaucratic drawers of him whom he willingly calls "a cretin of an art critic." The mass media found long ago the comestible message which Dali's moustaches and his works contained, such as *Christ of Saint John of the Cross* (colorplate 35), even if the critic "of old modern art" of a big weekly American newspaper had considered this painting, when it was first shown in London in 1951, "a slightly banal image."

Salvador Dali has every reason to be satisfied with his life. A phenomenon during his own epoch, he remains unscathed by the scepticism as to the destiny of the human species which weighs so heavily on occidental civilization. While walking the streets of Figueras, he can glimpse the reticular cupola designed by Emilio Pérez Piñero — whom Dali calls "the genius of architecture" — the byzantine dome of which crowns with transparency the old municipal theater transformed into the Teatro-Museo Dali. What more could a Spanish painter who loves chocolate and his country possibly want than to see his works reproduced along with those of Fragonard on candy boxes and to have his country offer him a museum in his native town? The fantastic itinerary of this destiny, which appears in filigree work in the pages of this book, has left its traces in the dusty road to glory. Where will he lead, who at the age of six wanted to be a cook and at seven Napoleon? "Oh, Salvador Dali, now you know that, if you play at being a genius, you will surely become one!" Soon: Peking!

COLORPLATES

52. PORTRAIT OF HORTENSIA,
PEASANT WOMAN OF CADAQUÉS.
c. 1918–19. Oil on canvas, 13 7/8 × 10 1/4".
Private collection

COLORPLATE 1

Portrait of Lucía

c. 1918. Oil on canvas, 17 1/8 × 13". Private collection

This is one of the first portraits Dali painted. It depicts his nurse, Lucía Moncanut, as an old woman. Hired by Dali's family to look after him and his sister, Ana-María, in Figueras, she occupies an important place in the Dalinian iconography. When this picture was painted, the children having grown up, Lucía was taking care of their maternal grandmother, Ana; Dali remembers having worked at the same time on a portrait of Ana, in profile, holding in her hand a similar dahlia or perhaps a carnation — Dali can't remember which — like the Moorish carnations that Spanish women were in the habit of placing behind their ears or sticking in their hair. Dali thinks that he painted Lucía's portrait while he had tonsilitis and she was hovering around him as she used to do when he was a child in order to tell him stories.

We know that Lucía never left the apartment on Monturiol Street; she never went to Cadaqués. It is she, however, whom the painter confused with the silhouette of Lydia, the wife of a fisherman of Cadaqués, when

he painted the figure in the center of a picture such as *The Weaning of Furniture-Nutrition* (fig. 31). Lydia was used as the archetype for the heroine of a novel by Eugenio d'Ors, *La Ben Plantada* (The Well-Planted Woman). Her paranoiac personality made a great impression on Picasso and Fernande Olivier when they visited the little port of Cadaqués in 1910.

Lydia's son and Dali's father figured out a few years ago that *Portrait of Lucia* must have been painted c. 1918. Even if it had been done at the end of the following year, it is a good example of Dali's impressionistic style, as in the *Portrait of Hortensia, Peasant Woman of Cadaqués* (fig. 52); *Old Man at Twilight* (fig. 6); and numerous landscapes of the same period. The mastery of his touch, the precision with which he has rendered the half-blind eyes of the old woman, and the richness of color show what a keen eye the young painter had, even at the age of fourteen.

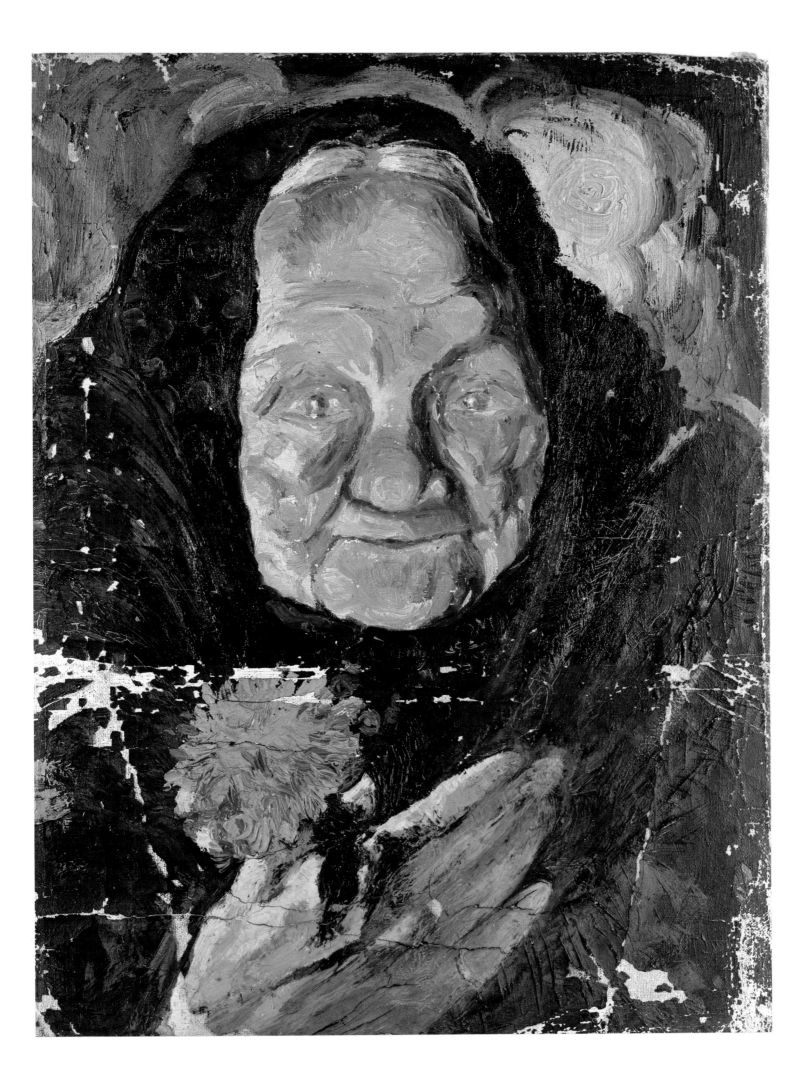

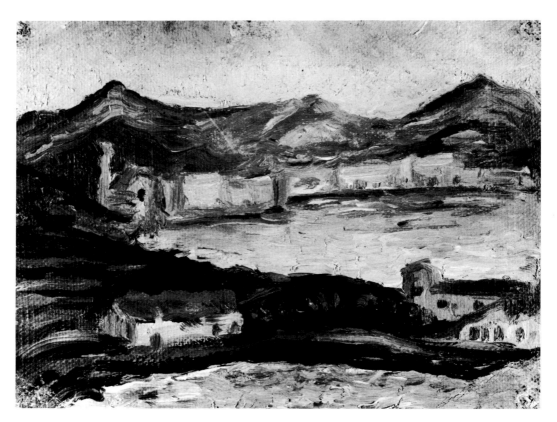

53. CADAQUÉS. c. 1917. Oil on canvas, 7 1/2 × 10 1/2".
Collection Antonio Pichot Soler, Cadaqués

COLORPLATE 2

Self-Portrait with the Neck of Raphael

c. 1920–21. Oil on canvas, 21 1/4 × 22 1/2".
Private collection

All Dali's self-portraits reproduced in this book were painted before 1929 or after World War II; there are only a few canvases and drawings of the Surrealist period where he has depicted himself. Here we see him at the age of about seventeen at the top of the road that dominates all Cadaqués and leads to the cove of Seboya. The village appears in the background, sparkling in the morning sunshine. Behind Dali we see what is nearly an island, Sortell, the estate of the Pichots. Dali often went to this spot to paint the landscape in different lights. Speaking of this canvas, which is small in size, he relates: "At that time they called me Señor Patillas because I wore sideburns; it was in the middle of my student days at the Academy of Fine Arts, in 1921, when these sideburns were the longest. At the time of this painting, my hair

was starting to grow but not as much. It was painted by the light of the setting sun. Sometimes I got up at dawn and I worked on four or five pictures at the same time. My canvases were brought to me, but I myself was wearing an outfit with all the brushes attached to it by strings, which made me into a sort of hippie! It allowed me immediately to grab the brush I needed. Later I wore a mechanic's suit which was so smeared with glue as to become a veritable suit of armor." All Dali's interest is turned to the atmosphere of the picture; for the sake of accuracy, he had to return to the scene every day at the exact hour when the sun hit the village, leaving the cliff in the foreground in the shadow, where he placed himself. Then he worked on the likeness of himself in front of a mirror in his studio during the hot hours of the day.

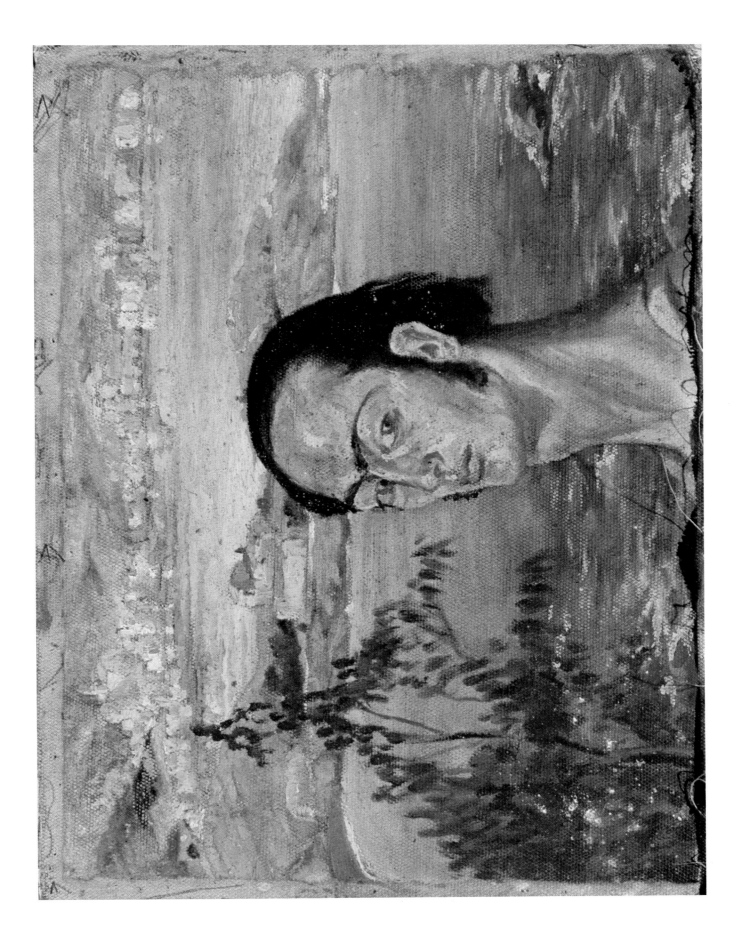

COLORPLATE 3

Llaner Beach in Cadaqués

c. 1921. Oil on cardboard, 24 3/4 × 35".
Formerly Collection José Marín Lafuente, Figueras

From his earliest childhood Dali spent his vacations in Cadaqués. When we compare this landscape with another work painted at the same time, *The Bathers on Llaner Beach*, we feel the voluptuousness of a summer beside the Mediterranean Sea. Here the artist has painted the Llaner Beach in front of the family home, during the bathing hour. In the foreground his family, his aunt "la Tieta," and his sister, Ana-María, with some friends, the Salleras, are just returning from Mass. One of the family boats — the Dalis had two, *Nebuchadnezzar* and *Wilson*, the latter so named because at that time Salvador's father greatly admired the president of the United States — is still pulled up on the sandy beach, awaiting the afternoon boat ride. Dali remembers the houses with dry-stone walls which have since been torn down and the last rocky promontory, *"la punta den pampa*, where one could see in the distance the village boys come to bathe in the nude. At noon this point was flesh pink." His sister, Ana-Maria, recalls that he had asked the group to pose in the landscape for a moment so that he could put the figures in the proper places on the canvas then and there, in oil, without a preliminary pencil sketch, working out the whole later in his studio. This canvas should be classed in the period when Dali was using the pointillistic technique of Seurat.

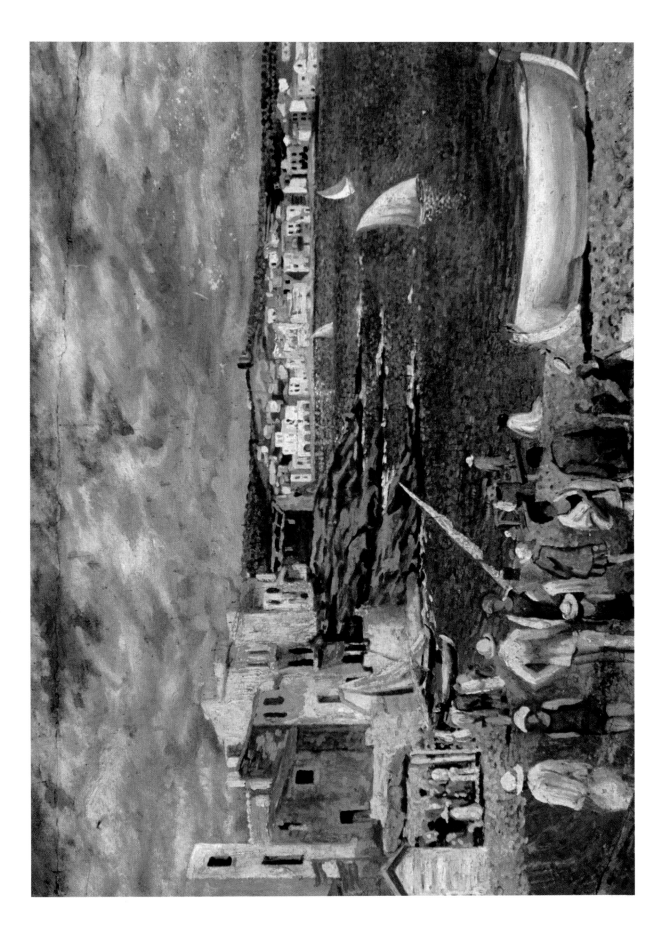

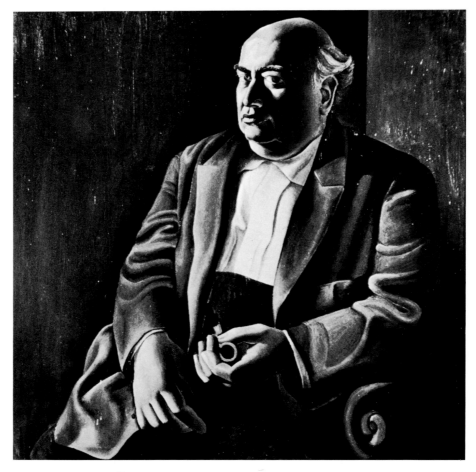

54. Portrait of the Artist's Father (entire work)

Colorplate 4

Portrait of the Artist's Father *(detail)*

1925. Oil on canvas, 39 3/8 × 39 3/8".
Museum of Modern Art, Barcelona

The imposing presence in this portrait reveals, better than is possible in writing, the strong personality of the notary Salvador Dali y Cusi, the artist's father. Dali has superbly portrayed that paternal authority against which less than five years later he was destined to revolt, shortly after his meeting with Gala. He recounts that his father always intimidated him more than anyone else. This feeling is clearly shown by the pose of the sitter, the construction of the picture, the lighting, and the neo-realistic technique inspired by André Derain. The portrait was painted in the summer of 1925 at Cadaqués in fifteen sittings; Dali, who cannot remember exactly how much time he has spent on a picture, claims to have done it very quickly. We may better appreciate his keen sense of observation if we compare the likeness in this portrait with a pencil drawing of the same period, *Portrait of the Artist's Father and Sister,* and a photograph in which he posed with his father about 1948, twenty-three years later. The exactness of detail in this painting has the merit of causing memories from the time Dali was painting the work to come back to him. Thus,

speaking of the pipe held by his father in his left hand, he remembers that the latter "was always smoking and I myself used to smoke a pipe with wood tar because I thought that I was a detective like Sherlock Holmes, without tobacco. But, if I was only pretending, he was really smoking." The family did not think that his right hand was placed in a suitable position, but he himself considered it perfectly normal for a father to put his hand wherever he wanted it, even if this spot was exactly where his paternal virility was! In 1925 Dali exhibited this picture for the first time, in Barcelona at the Dalmau Gallery. In his *Secret Life,* speaking of this realistic period influenced by Derain and Vermeer, he wrote: "Paris heard rumors that a new painter had just been discovered in Spain. While passing through Barcelona, Picasso had seen my *Girl's Back* and had praised it highly. I knew that on the day of my arrival in the capital I would put them all in my bag." Later he used this realistic technique in most of his Surrealist works and he remains faithful to it even today in certain canvases, when this seems necessary to him.

54

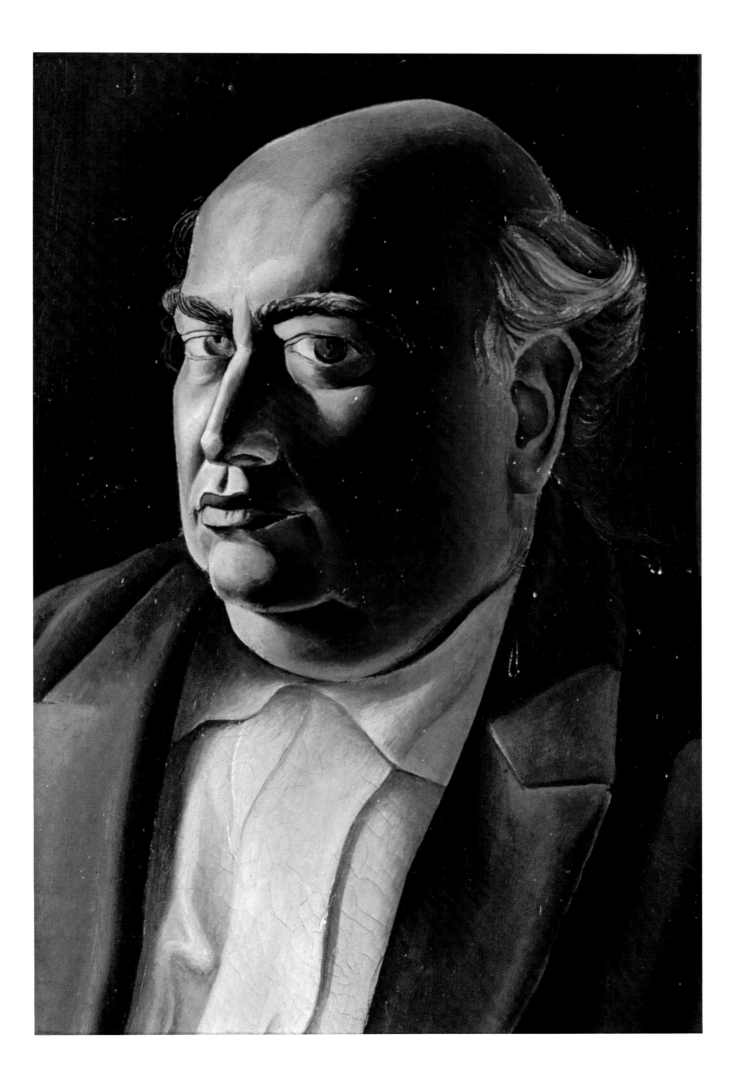

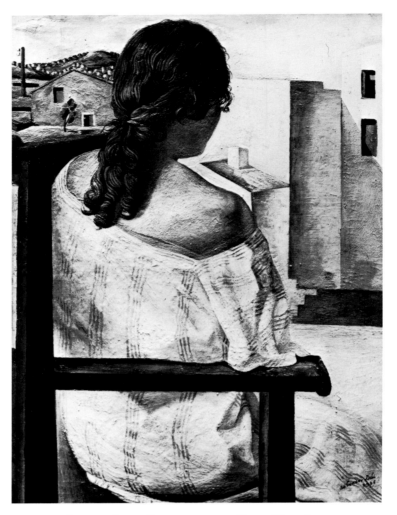

55. SEATED GIRL, SEEN FROM THE BACK (THE ARTIST'S
SISTER). 1925. Oil on canvas, 42 1/2 × 30 1/4".
Museum of Contemporary Art, Madrid

COLORPLATE 5

Girl Standing at the Window

1925. Oil on canvas, 40 1/2 × 29 1/8".
Museum of Contemporary Art, Madrid

As a youth Dali did numerous portraits of his sister, Ana-María, often painted on copper and very small in size. This one, larger and on canvas, is considered one of the most beautiful. It was shown at Dali's first one-man exhibition, in Barcelona at the Dalmau Gallery in November 1925. In her book *Salvador Dali, visto por su hermana*, Ana-María wrote: "The portraits that my brother painted of me during this period are innumerable. Many were simple studies of hair and a bare shoulder." She remembers the long hours of posing during which, serving as his model, she never tired of "looking at the landscape which from then on and forever was a part of me. Indeed Salvador always painted me near a window!" Such a portrait is *Seated Girl, Seen from the Back* (fig. 55). In

Girl Standing at the Window, Ana-María poses in the room on the first floor of the paternal home in Cadaqués which Salvador used as a studio. When corresponding with Ana-María, Lorca wrote: "My stay in Cadaqués was so marvelous that it seemed to me like a beautiful dream, particularly the awakenings with what one sees from the window." For the painter this room remains associated with a closer, sadder vision. In 1950, while he was working on the little rhinoceros painted in bas-relief on the base of *The Madonna of Port Lligat* (colorplate 34), he was told of his father's death. It was there, in front of that window, that he had seen him for the last time.

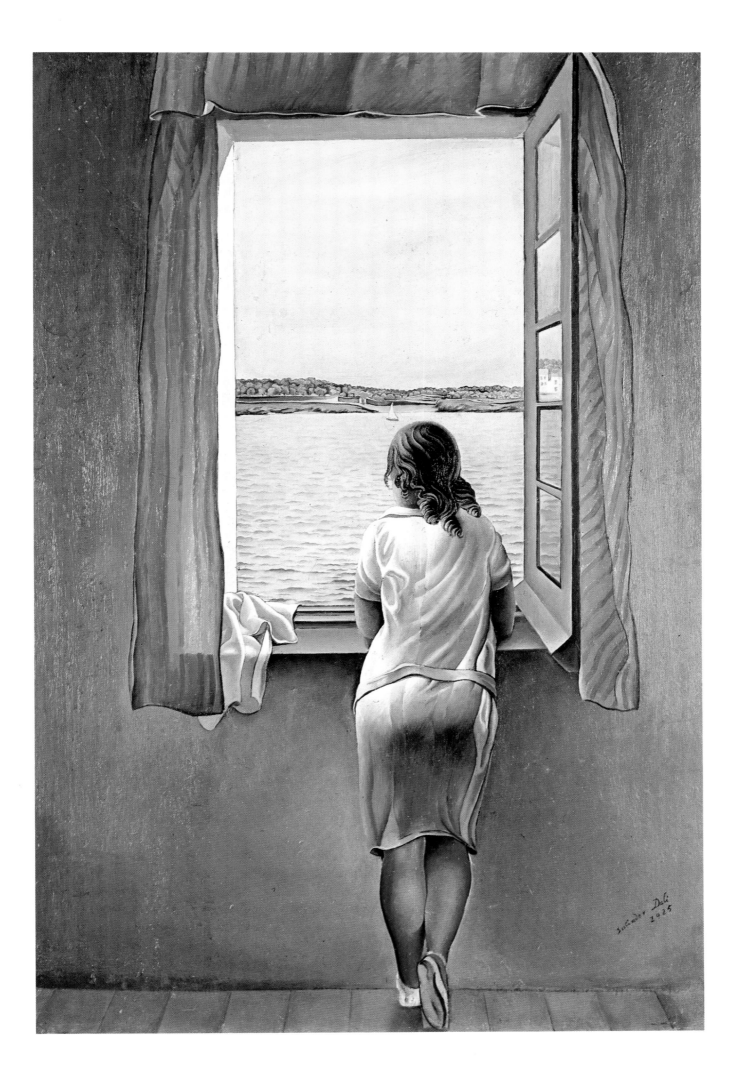

Reclining Woman

1926. Oil on panel, 10 5/8 × 16".
Salvador Dali Museum, St. Petersburg, Florida

This kind of composition first appeared in the middle of 1926, when Dali was painting landscapes, portraits, still lifes, and Cubist compositions at the same time. There are not more than six canvases done in this manner, in which one sees this type of ample female creature stretched out on the sand or on the rocks. These figures visibly show the influence of the works of Picasso from the period called neo-realistic, between 1920 and 1922. Dali groups them instead in what he calls "the time of neo-Cubist academies." Lorca, Dali's sister, and other friends were in the habit of giving these paintings a Catalonian explanation coming from the peculiar patois of Cadaqués — *trossos de Coniam*, which means, when referring to a person, that he is completely lacking in intelligence and is "totally physical, a sort of vegetable!" Dali never used it literally in the pejorative sense; on the whole he was interested in the vegetative and soft aspect of the figure, in spite of the apparent Cubist treatment, and its opposition to the hard-ness of the rocks.

Reclining Woman was painted in Cadaqués in the studio where Dali had hung reproductions of Picasso on the wall, one of which he had torn from the magazine *L'Art d'aujourd'hui*. This page depicted two women running on the beach; it is probably from a backdrop curtain painted shortly after the end of World War I for one of Diaghilev's Russian ballets. Several other pictures of this series were done in Figueras. At the time, Dali was intrigued with geometry, with regulative diagrams and everything that related to the golden section. In *Reclining Woman* the diagonal construction, not so visually evident as in *Figure on the Rocks — Penya Segats*, or even in *Venus and Cupids*, is, however, very definite: the complete structure of the subject radiates from the exact point of the intersection of the diagonals, found slightly below the navel, which is the optical center of the picture.

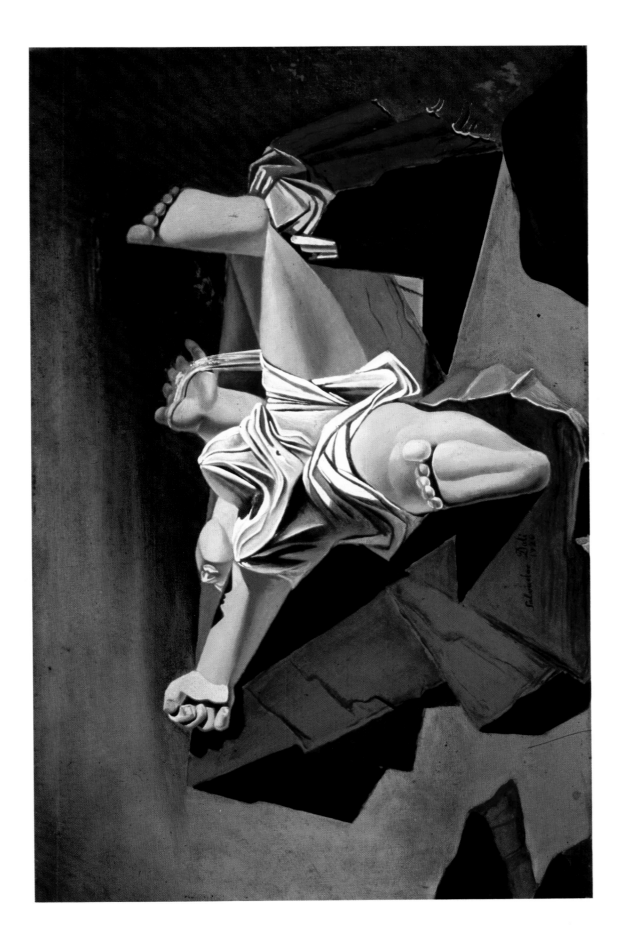

56. HARLEQUIN. 1927.
Oil on canvas, 74 7/8 × 55 1/8".
Museum of Contemporary Art, Madrid

COLORPLATE 7

Barcelonese Mannequin

*1927. Oil on canvas, 78 3/4 × 59".
Private collection*

In this large painting dated 1927 — painted in Figueras, following experiments started in Madrid as early as, the end of 1921 — the influence of the masters of Cubism is perfectly visible, particularly that of Juan Gris, for whom Dali has always manifested the keenest admiration. He considers the Madrilenian painter the greatest of all the Cubists, and he acknowledges Picasso's title as the giant of our times, but rather for his vital genius as a destroyer and his certain way of seeing with a painter's eye than for his painterly qualities, even if these are exceptional.

This painting was given the title *Barcelonese Mannequin* later. The female figure was inspired by a young girl of Figueras, Ramoneta Montsalvatje, who was one of a small group of friends. She was very pretty and personified elegance, evoking for Dali the memory of the mannequins and women of the world in Barcelona and Madrid. This is evident in the treatment of the feet and the shoes, especially the one in front; attention must also be called to the appearance of the fish-sex, a theme used frequently later on by the Surrealists. At this time Dali had already had the opportunity to see the paintings of post-Cubist artists in the pages of magazines to which he had subscriptions (such as *L'Amour de l'art, L'Art d'aujourd'hui, L'Art vivant, Revista de occidente, L'Esprit nouveau, Studium, Museum, D'Ici d'alla, La Gaseta de les arts, L'Amic de les arts, Variété, Der Querschnitt*). Most of the Cubist canvases of the years 1926 and 1927, such as *Barcelonese Mannequin*, a self-portrait entitled *Harlequin* (fig. 56), and also *Still Life by the Light of the Moon* (fig. 15), are all very large oils.

60

Bird

1928. Oil on panel with sand and gravel collage, 19 1/4 × 23 5/8″.
Private collection

Dali's bestiary broke loose from reality at the end of 1926 to become altogether fantastic during 1928, which marked a very important period of transition in the painter's work. This picture is part of a series in which the influence of Max Ernst is clearly visible, more particularly so in a painting such as *La Belle Saison* in the Urvater collection in Brussels.

However, Max Ernst's influence is only superficial. Dali used it momentarily, with others, because at that time, already trying to transcribe his dreams, he took advantage of this material just as he made use of the Mediterranean sand and gravel that he glued to the surfaces of the picture. Let's make no mistake about it, in the works of this Mediterranean painter from the north of Spain, the monsters are nothing at all like those which, driven mad by the silent darkness of the nordic forests, spring up in the works of Hieronymus Bosch and all German civilization.

In a taped interview, speaking of the baroque, Dali told me: "The luminosity of the rough part of the seashells from the grottoes of the Mediterranean gave birth to the grotesque, succeeding in thus making the joyous light of its own roots and its most obscure branches burst forth. While the monsters of Bosch are the products of music, of the forest, of the gothic, of obscurantism, the grotesque figures in Raphael come directly from Pompeii, from humanism and Mediterranean intelligence; all the grotesque beings of Bosch are only a protest: it's the indigestion that the knights had upon returning from the Crusades! A Pantagruelian way of protesting against the Greco-Roman humanism. The grotesque figures painted by Raphael in the Vatican, on the contrary, are the affirmation of this intelligence, of this humanism, a way of dominating the monsters. With Raphael it is the conquest of the irrational, while the monsters of Bosch are conquered by the irrational. There's the whole difference. And I myself am the anti-Hieronymus Bosch. Let us succeed in making monsters but may they be completely antagonistic and dissimilar! Dali, he is pure Mediterranean!"

All the pictures with collage of gravel and sand were painted at Cadaqués. The principal ones are *Unsatisfied Desires* (colorplate 9), *Bathers*, and *Thumb*. "The interesting thing in this *Bird*," Dali has said, "is that with its side already monstrous, it carries in its entrails a thing which is a foetus and instead of the foetus being that of a bird, it's a cat! The moon is there as in many other canvases of this period." Going on, apropos the influence of Max Ernst, he has stated, "It is not the analogies which afford interest but the dissimilarities, even if I used a painting by Max Ernst. In the same way, the *Phedra* of Euripides becomes exactly the opposite when dealt with by Racine. In this picture it is the same thing; instead of seeing an analogy with Max Ernst one should see what is absolutely the contrary. According to me, I perhaps take something of Max Ernst as a point of departure, but because of my Mediterranean heritage and my almost scientific side, I create with the elements torn from the soil of Cadaqués — that is, from the Mediterranean — a bird which carries an animal inside it, a monster which has nothing to do with the lucubrations of the Germans. In general, the critics see the petty analogy immediately and draw superficial or false conclusions from it. They are mistaken, but that is of no importance. Even false, only the amount of information counts."

57. ANTHROPOMORPHIC BEACH. 1928.
Oil on canvas with cork and
carved, polychrome stone finger
in the center of the cork
float, with sponge painted red,
25 1/4 × 17 1/2".
*Salvador Dali Museum,
St. Petersburg, Florida*

COLORPLATE 9

Unsatisfied Desires

1928. Oil on cardboard with gravel collage, 30 × 24 3/8".
Private collection

This picture was painted in Cadaqués during the summer of 1928. Dali sent it along with another work, *Female Nude* (fig. 17), to the Salon d'Automne which was held at Maragall's Gallery in Barcelona. The directors, frightened in advance at the probable reactions of the public to the obviously sexual allusions contained in the paintings, preferred to withdraw them.

"Then," Dali relates, "in protest I gave a lecture at the Sala Pares which triggered a frightful scandal because I had insulted all the painters who were doing twisted trees. This was the first of three scandalous lectures that I was to give in Barcelona. The second took place a few years later at the Atheneo, where I thoroughly insulted the name of the founder of the society who organized the lecture — a man whose memory was respected throughout all Catalonia — by calling him the great pederast and the great hairy putrified man. . . . Afterwards, I wasn't able to continue to say very much; everyone threw chairs and broke up everything. The police had to protect me so that I could leave and get as far as the car. The third one was a lecture given with René Crevel during the Surrealist era at a place where the anarchists met called the 'Popular Encyclopedia.' They had put a loaf of bread on my head just like that in *Retrospective Bust*. I spoke about sex, about testicles, about everything, to such a point that an anarchist got up and said: 'It's intolerable that you should use such obscene language in front of our wives, because we are accompanied here by our wives!' It was Gala's turn to stand up, and she replied: 'If he says this in front of his own wife, which I am, he can say it in front of your wives.'

"It is one of the first pictures of the period when I used the gravel from the beach of Llaner as collage; I used to go rather to Sortell near the Pichots' house to fish for gobies or other things. I picked up cork floats, a little here and there, at random." These pictures with the gravel and the cork floats were the beginning of a series which Dali considered the most important before Surrealism: canvases which were practically white with only a few ideographic signs and feathers glued on them, such as *Fishermen in the Sun* (fig. 18).

64

58. THE BATHER. 1928. Oil on panel, 25 × 29 1/2". *Collection Mr. and Mrs. A. Reynolds Morse, on loan to Salvador Dali Museum, St. Petersburg, Florida*

COLORPLATE 10

Inaugural Gooseflesh

*1928. Oil on cardboard, 29 5/8 × 24 5/8".
Private collection*

Dali gave this picture its title in 1964. Here the diagonal construction is again used. The visible material in the picture would seem to place it with the works painted in 1927 such as *Blood Is Sweeter Than Honey* (fig. 14) in that series which Lorca called "Apparatus Forest." *Inaugural Gooseflesh* is painted in the same style but as an afterthought; it is the result of the works of this period and of the paintings done at the same time in 1928 such as *Bathers* with the gravel collage. The composition is already the product of a hypnagogic image similar to that which Dali repeated often in his Surrealist works — we see an example of it in *Portrait of Paul Eluard* (fig. 19) — little rodlike cells in suspension above an oblong object. Dali has given an explanation of it in his book *Le Mythe tragique de L'Angélus de Millet*. "In 1929, for the first time, one of those very clear images appeared to me, most probably following many others, although I cannot find any antecedent for it in my memory. This happened in Cadaqués when I was in the act of pulling violently at the oars, and it consisted of a white shape illuminated by the sun, stretched out at full length, cylindrical in form with rounded extremities, showing several irregularities. This form is lying down on the maroon-purplish-blue soil. All its periphery is bristling with little black rodlike cells appearing in suspension in all directions like flying sticks." Dali continues, "The numbering in the pictures probably corresponds to my unconscious interest in the metric system. In June 1927 I had written an article, 'The Martyrdom of Saint Sebastian,' which appeared in *L'Amic de les arts*, about which Lorca had said that it was the most poetic text he had ever read. In this article I explained how one could measure the suffering of Saint Sebastian just as with degrees on a thermometer, each arrow being a sort of gradation adding and measuring the amount of suffering. It was at the same time that Lorca wrote in his 'Ode to Salvador Dali,' 'A desire for forms and limits overwhelms us. The man who measures with the yellow yardstick comes.' At that time I was preoccupied with all the systems of weights and measures, and numbers were appearing everywhere. I was already preoccupied with the metric system, the numerical division of worldly things."

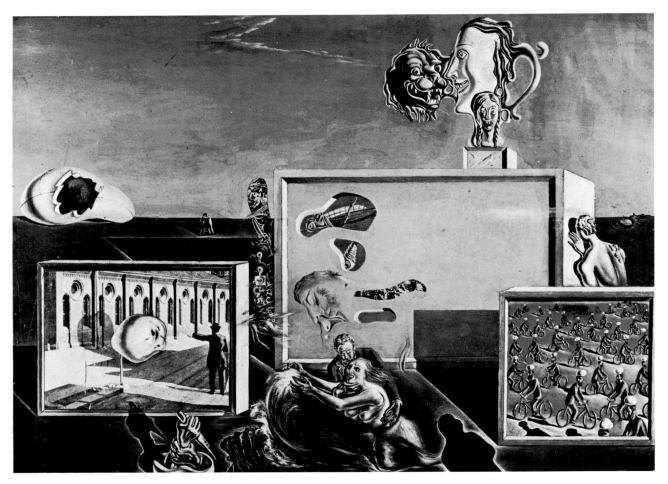

59. ILLUMINED PLEASURES. 1929. Oil on panel, 9 1/2 × 13 5/8″.
The Museum of Modern Art, New York. Collection Harriet and Sidney Janis

COLORPLATE II

The Enigma of Desire: My Mother, My Mother, My Mother

1929. Oil on canvas, 43 5/8 × 59″. Former collection O. Schlag, Zurich

This great composition, among the first works of the Surrealist period, is one of the most important. Dali painted *The Enigma of Desire* in Figueras just as he was finishing *The Lugubrious Game*.

"I did it at the same time as *The Great Masturbator*" (fig. 22), he relates, "immediately after summer. My aunt had a large dressmaking workroom and it was there that I did all these pictures. *The Great Masturbator* was taken from a chromo that I had which depicted a woman smelling a lily. Naturally the face is mixed with memories of Cadaqués, of summer, of the rocks of Cape Creus." *The Enigma of Desire* was the first work sold by the Goemans Gallery during Dali's first one-man exhibition there in 1929; the Viscount of Noailles bought it together with *The Lugubrious Game*. Just as he was painting this canvas, Dali found a religious chromo-lithograph on which he wrote, "Sometimes I spit with pleasure on my mother's portrait," commenting that what he did then "had a quite psychoanalytical expla-

nation, since one can perfectly well love one's mother and still dream that one spits upon her, and even more, in many religions, expectoration is a sign of veneration; now go and try to make people understand that!"

In the baroque appendage that elongates the visage, we recognize the geological structures of the rocks of the region near Cape Creus eroded by the wind, mixed with the fantastic architecture of Antonio Gaudí, "that gothic Mediterranean," whose work Dali had seen as a child in Barcelona.

The second part of the title, *My Mother, My Mother, My Mother*, was inspired by one of Tristan Tzara's poems, "The Great Lament of My Darkness," which appeared in 1917. Dali considers *The Enigma of Desire* to be one of his ten most important paintings. The little group on the left depicts Dali himself embracing his father, with a fish, a grasshopper, a dagger, and a lion's head.

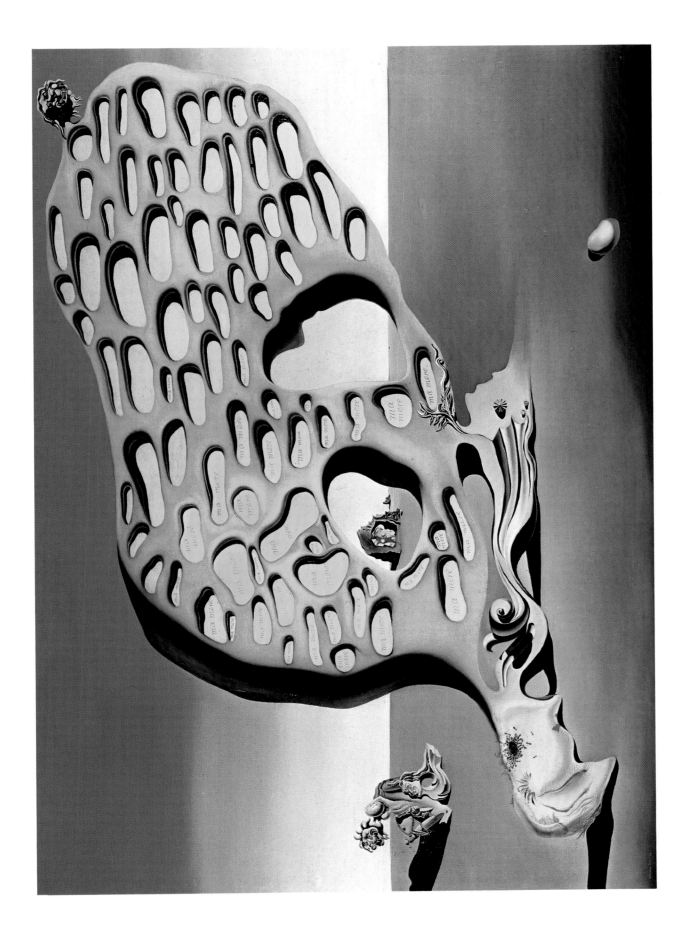

60. INVISIBLE SLEEPING WOMAN, HORSE, LION. 1930. Ink, 18 1/2 × 24″. *Private collection*

COLORPLATE 12

Invisible Sleeping Woman, Horse, Lion

1930. *Oil on canvas, 19 5/8 × 23 5/8″. Private collection, Paris*

This analytical work is one of the first painted in the new house in Port Lligat during the summer of 1930. In his numerous written works Dali has given us much information about this picture. "A month after my return from Paris," he writes, "I signed a contract with George Keller and Pierre Colle. Shortly after in the latter's gallery I exhibited my *Invisible Sleeping Woman, Horse, Lion*, fruit of my contemplation at Cape Creus." The Viscount of Noailles bought this oil. *Invisible Sleeping Woman, Horse, Lion* must be considered the most important painting after *The Invisible Man* among Dali's early experiments with double images. The permanent theme which predominates over all the others is that of the persistence of desires.

Speaking of this picture, Dali has given a definition: "The double image (the example of which may be that of the image of the horse alone which is at the same time the image of a woman) can be prolonged, continuing the paranoiac process, the existence of another obsessive idea being then sufficient to make a third image appear (the image of a lion, for example) and so forth, until the concurrence of a number of images, limited only by the degree of the capacity for paranoiac thought." The violently erotic character of the group of *fellateurs* metamorphosed into the forelegs and the head of the horse is veiled by the immutable aspect of the ensemble, obtained with the help of an absence of dense shadows and violent colors, as well as by the geological character of the forms. Dali said of these models: "They are always boats which seem to be drawn by exhausted fishermen, by fossil fishermen."

Dali painted three pictures of the same subject with different titles. One of the three was destroyed during the demonstrations which broke out when the film *L'Age d'or* was being shown at Studio 28 in Paris on December 3, 1930.

70

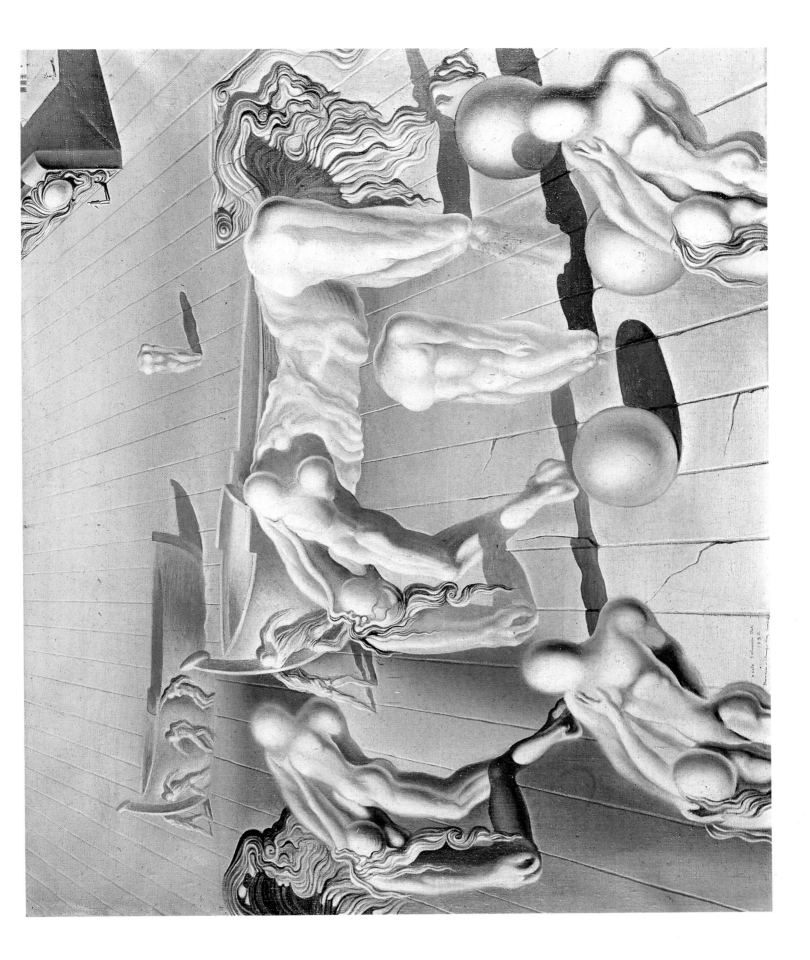

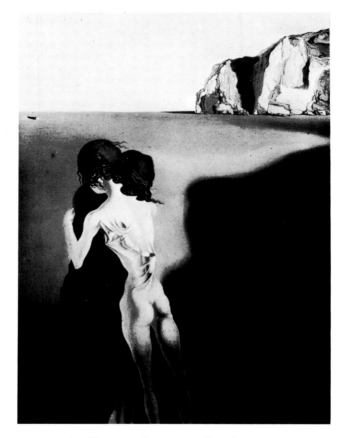

61. DIURNAL ILLUSION: THE SHADOW
OF A GRAND PIANO APPROACHES. 1931.
Oil on canvas, 13 5/8 × 10"
Private collection

COLORPLATE 13

Shades of Night Descending

1931. Oil on canvas, 24 × 19 5/8".
Collection Mr. and Mrs. A. Reynolds Morse, on loan to Salvador Dali Museum, St. Petersburg, Florida

The obsessive character of this work is made evident by one of the less important elements and the least noticed by the viewer: the measureless shadow which is spread out in the bottom part of the canvas. Its obsessional power is obtained by having in the center a rock whose shadow is much less dense than that of the one in the foreground. In appearance this reef seems to be a rock like the others; however, it is already constructed in such a way that its shadow bears a resemblance, due to its design, to the one in the foreground. Their source is moreover quite different, and it is there that the painter has successfully applied his famous paranoiac-critical method.

The shadow in the foreground is that of a concert grand piano, an instrument which holds a predominant place in many of Dali's Surrealist compositions, such as *Diurnal Illusion: The Shadow of a Grand Piano Approaches* (fig. 61); *Average Bureaucrat; Six Apparitions of Lenin on a Piano* (fig. 24); or *Myself at the Age of Ten*

When I Was the Grasshopper Child (fig. 29). This piano is "the one that belonged to the Pichots with its shadows," Dali relates; "I was impressed by these shadows in the setting sun, near the tall cypress in the interior court of the house, and another time when they had brought the instrument onto the rocks beside the water." The spectral victory standing in the lower-right corner of the picture is concealing heteroclite objects, half-hidden under the drapery in whose tortured folds the figure is wrapped. Two of these things, a glass and a shoe, are used with the same impact to stretch out the skin on the back of the figure in *Diurnal Illusion*. Speaking of his fetishism, Dali has said, "It was a question of all the fetishes and slippers of my childhood fossilized underneath the membranes of my anguish, all mimetized at Cape Creus." Shoe fetishes appear often in scenes of "bureaucratic cannibalism," where one can see the most varied figures: a girl, Nietzsche, or Maxim Gorky devouring a high-heeled shoe.

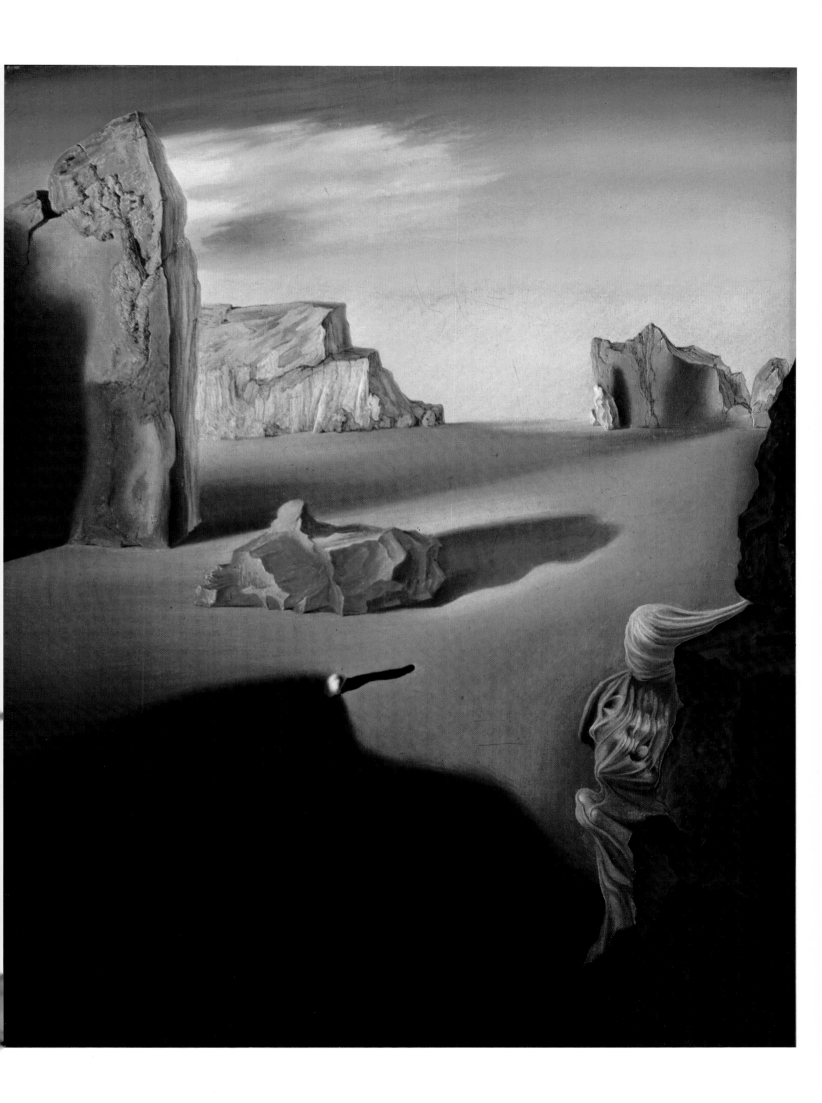

62. TWO FACES OF GALA. c. 1933. Ink, 11 7/8 x 8 1/4".
Collection A. F. Petit Gallery, Paris

Portraits of Gala

These two little portraits show Gala shortly after her meeting with Dali. Reproduced here in exact size, they were painted in oil, with an interval of a year between them: the upper one on an olive panel, from life, in Port Lligat, the other on a postcard with an iridescent background. Gala is Dali's one and only inspiration. Her importance equals that of the most celebrated mistresses of the greatest men.

As the wife of the poet Paul Eluard, she inspired him to write verses which are numbered among the most beautiful in contemporary poetry: "she whom I love, Gala, who hides my life from me and shows me love."

André Thirion pays her the greatest homage, writing: "Dali felt for Gala an exclusive and devouring passion," and "he painted then some pictures which are considered among the most moving and most beautiful tokens of love that man has ever given a woman."

Dali offered her this constant declaration of love in these lines written in 1971: "I call my wife: Gala, Galutchka, Gradiva (because she has been the one who advances) — Gradiva is the heroine of a novel by W. Jensen interpreted by Freud; Olive (for the oval of her face and the color of her skin), Olivette, the Catalonian diminutive of Olive, and its delicious derivatives: Olihuette, Oriuette, Buribette, Burkueteta, Suluhueta, Solibubulete, Oliburibuleta, Cihuetta. Also called Lionette (little lion, because she roars like the Metro-Goldwyn-Mayer lion when she is angry); squirrel, tapir, little Negus (because she looks like a pretty little forest animal); bee (because she brings me the essence of everything which, transformed into honey, nourishes the buzzing hive of my brain). Her glance pierces walls (Paul Eluard). She gave me the rare book on magic which was necessary to the elaboration of the paranoiac image desired by my subconscious mind for the photography of an unknown painting destined to reveal a new aesthetics, with the advice for saving one of my images that was too subjective and tainted with romanticism. I also call her *Gala-Noisette poilue* (because of the very fine down which covers her cheeks) and also *Quatre cloches*, because she reads aloud to me during my long séances of painting, producing a murmur like the sound of four clocks, which plunges me into a state where I am able to learn everything that, without her, I would never have known."

COLORPLATE 14

c. 1932–33. Oil on panel, 3 1/4 x 2 3/8".
Collection Mr. and Mrs. A. Reynolds Morse, on loan
to Salvador Dali Museum, St. Petersburg, Florida

COLORPLATE 15

1931. Oil on postcard, 5 1/2 x 3 3/4".
Private collection

63. Illustration for *Les Chants de Maldoror*
by the Count of Lautréamont. 1933–34.
Etching, 8 3/4 x 6 1/2".
Private collection

COLORPLATE 16

Gala and the Angelus of Millet Immediately Preceding the Arrival of the Conic Anamorphosis

1933. Oil on panel, 9 1/2 × 7 3/8".
Formerly Collection Henry P. McIlhenny, Philadelphia

In this interior scene reproduced here in nearly actual size, Dali has brought together some of the characters or the obsessional themes of his Surrealist works before 1935. In the background, Gala, smiling, contemplates the scene; she is dressed in a richly embroidered jacket and is wearing a white cap with a transparent yellow-green visor which was then in style. The seated figure facing her, one hand placed on the table near a ball and a precariously balanced cube, is easily recognizable: it is Lenin. On the left, the indiscrete mustachioed man eavesdropping behind the door is Maxim Groky; on his head there is a lobster, a crustacean that the painter often places in equally anachronistic spots, even creating in 1936 an object known as the "lobster-telephone." Along with the soft watches, one of the most persistent obsessive images in Dali's works is undoubtedly *The Angelus* of Jean-François Millet, painter of the peasant world. This picture, which is in the Louvre in Paris, is reproduced in Dali's painting hung over the door. Dali attributes to this image an erotic significance explained in his book, *Le Mythe tragique de L'Angélus de Millet*, in which he describes in minute detail and at great length this delirious phenomenon. "In June 1932, there suddenly came to my mind without any close or conscious association, which would have provided an immediate explanation, the image of *The Angelus* of Millet. This image consisted of a visual representation which was very clear and in colors. It was nearly instantaneous and was not followed by other images. It made a very great impression on me, and was most upsetting to me because, although in my vision of the afore-mentioned image everything corresponded exactly to the reproductions of the picture with which I was familiar, it appeared to me nevertheless absolutely modified and charged with such latent intentionality that *The Angelus* of Millet 'suddenly' became for me the pictorial work which was the most troubling, the most enigmatic, the most dense and the richest in unconscious thoughts that I had ever seen."

64. ENIGMATIC ELEMENTS IN
THE LANDSCAPE (entire work)

COLORPLATE 17

Enigmatic Elements in the Landscape *(detail)*

1934. Oil on panel, 28 1/2 x 23 3/8".
Formerly collection Mr. and Mrs. Cyrus L. Sulzberger

This composition is entirely imaginary. It was painted in Paris in 1934 in the apartment that Dali and Gala occupied on the first floor at 88 rue de l'Université. The artist at work, pictured in the foreground seated in front of his easel, is Vermeer of Delft contemplating the wide plain of Ampurdán. Farther back one sees Dali as a child in his sailor's suit holding his hoop and standing beside his nurse of the type that he called Hitlerian nurses, much to the great fury of the Surrealists; still farther back two soft forms are coupled — they constitute part of that series of forms, erotic in character, used by Dali during his Surrealist period which he called "symbols" and of which he gave the following definition in the *Abridged Dictionary of Surrealism*: "Morphological, sub-cutaneous concretion, symbolic of hierarchies." At the lower right two little fragments appear splashed with the morning light. A silhouette, inexplicably and equivocally draped, rises up in front of a row of cypress trees — those that Dali used to see through the window in the courtyard of his school in Figueras; the tower is reminiscent of the one on the Pichots' property, called the Mill-Tower, near his birthplace; and behind this is a bell-tower typical of Catalonian churches.

The owner, Mr. Cyrus Sulzberger, considers this picture a real good-luck charm. As a young man he bought it while visiting the 32nd International Exhibition of Art at the Carnegie Institute in Pittsburgh in 1934, paying for it in installments of five dollars a week. Later he was forced to part with it.

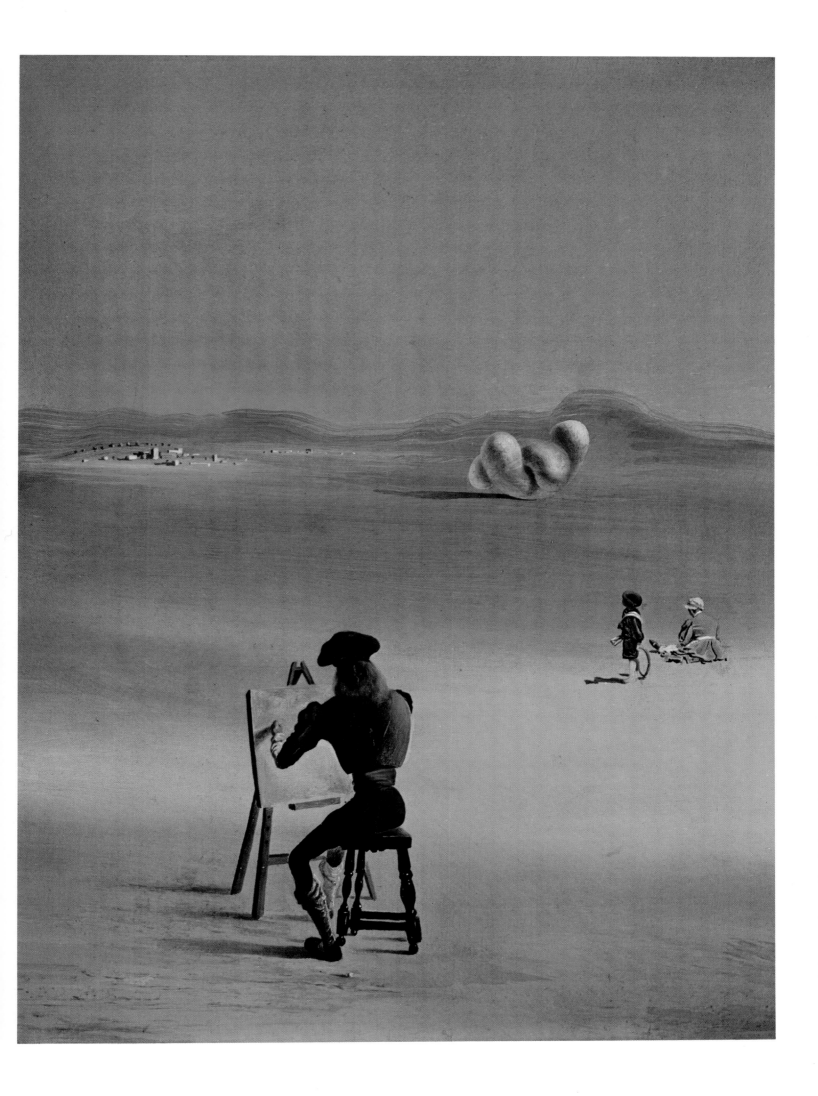

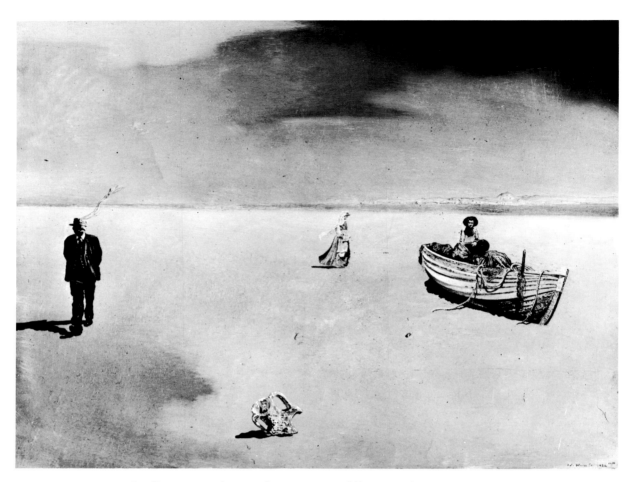

65. PARANOIAC ASTRAL IMAGE. 1934. Oil on panel, 6 1/4 x 8 5/8".
Wadsworth Atheneum, Hartford, Connecticut

COLORPLATE 18

Geological Justice

1936. Oil on panel, 4 1/4 x 7 1/2".
Private collection

This landscape belongs to the series of small paintings in the Edward James collection. It was in September 1970 that Dali gave it the title *Geological Justice;* the original title was *Anthropomorphism Extra-Flat.* The picture was shown for the first time in London in 1936 at the Lefevre Gallery.

Later Dali gave this explanation: "A sort of landscape-figure stretched out on the ground, the two arms crushed and open. It was a vision I had one time at Port Lligat of the sea at ebbtide on one of those days when it goes out farther than ordinarily. I saw a phenomenon of stones when the sea was pushed out by the currents and the tramontana. There were stones which formed a kind of sea-wall, the furrows making it look like a figure. Instead of putting it in Port Lligat, I placed it in surroundings which are more like the immense beach at Rosas, very obvious on an infinite stretch of shore. The rocks in the

background must be those near Bagur with the little Medas islands. It's the sea, but everything blends with the earth. The colors are very good. It is a question of the phenomenon of the tide, a minitide of the Mediterranean, there where there is practically none, but enough just the same, so that it produces even more of an effect."

Geological Justice was painted on a wooden panel in Port Lligat. As for many other pictures, the panel of olive wood was prepared by a carpenter called Costa who was shot during the Civil War; it was he who carved the frames, following the exact silhouettes, for *Couple with Their Heads Full of Clouds* (fig. 33). *Geological Justice* is a wonderful mixture of earth, beach, sea, waves, wind, gulf, and familiar coast — all of this inspired by a fleeting and limited vision from the accumulation of moments lived, but with an exceptional change of size.

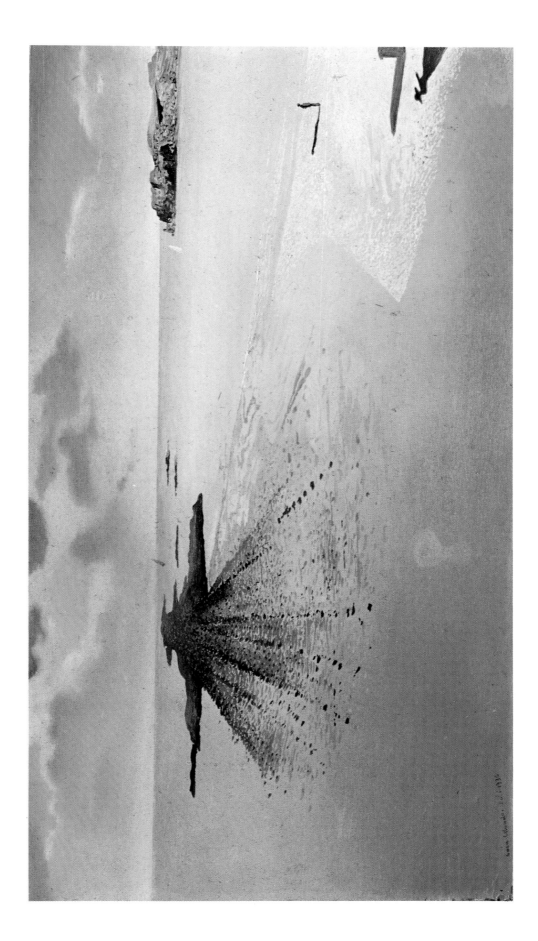

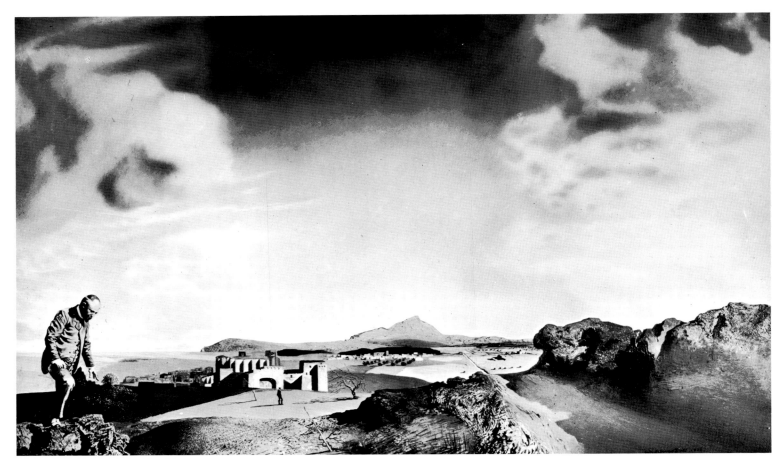

66. THE PHARMACIST OF AMPURDÁN IN SEARCH OF ABSOLUTELY NOTHING.
1936. Oil on panel, 11 1/4 x 20 1/2". *Folkwang Museum, Essen*

COLORPLATE 19

Sun Table

1936. Oil on panel, 23 5/8 x 18 1/8".
Museum Boymans-van Beuningen, Rotterdam

Salvador Dali's greatest intellectual and artistic honesty is probably never to have practiced any sophisticated, gymnastic aesthetics, in order to place the most disparate and most bizarre objects in his pictures. *Sun Table* is a good example of this. When he painted this composition, Dali did not know why he put a camel in with all the other elements which belonged to Cadaqués. Today he explains the premonitional character of this image by pointing out the package of Camel cigarettes placed at the feet of the silhouette of the young boy, probably himself, and he told me in 1970 that he had read an article by Martin Gardner which appeared in the magazine *Scientific American* under the heading "scientific games," in which the author explained that "the image on the cover of a package of cigarettes was full of extraordinary objective hazards — for example, the English word

'choice' written vertically in capital letters on the side of the package, when looked at in a mirror, remains unchanged and perfectly legible." In order to stress the out-of-context and obsessive character of a camel with all the magical aspects associated with the animal, Dali wrote later in his book *Dix recettes d'immortalité* that "seen through an electronic microscope it is possible to demonstrate that a camel is much less precise than a cloud." The table in the middle of the picture is a table from the café Le Casino in Cadaqués, on which are placed one duro and three glasses, the same glasses in which today is still served *tallat*, the Catalonian coffee with cream. The tiled floor is what was being put in Dali's kitchen at the time that he was painting this picture, having installed himself at a glass-topped table in the dining room of the house in Port Lligat.

82

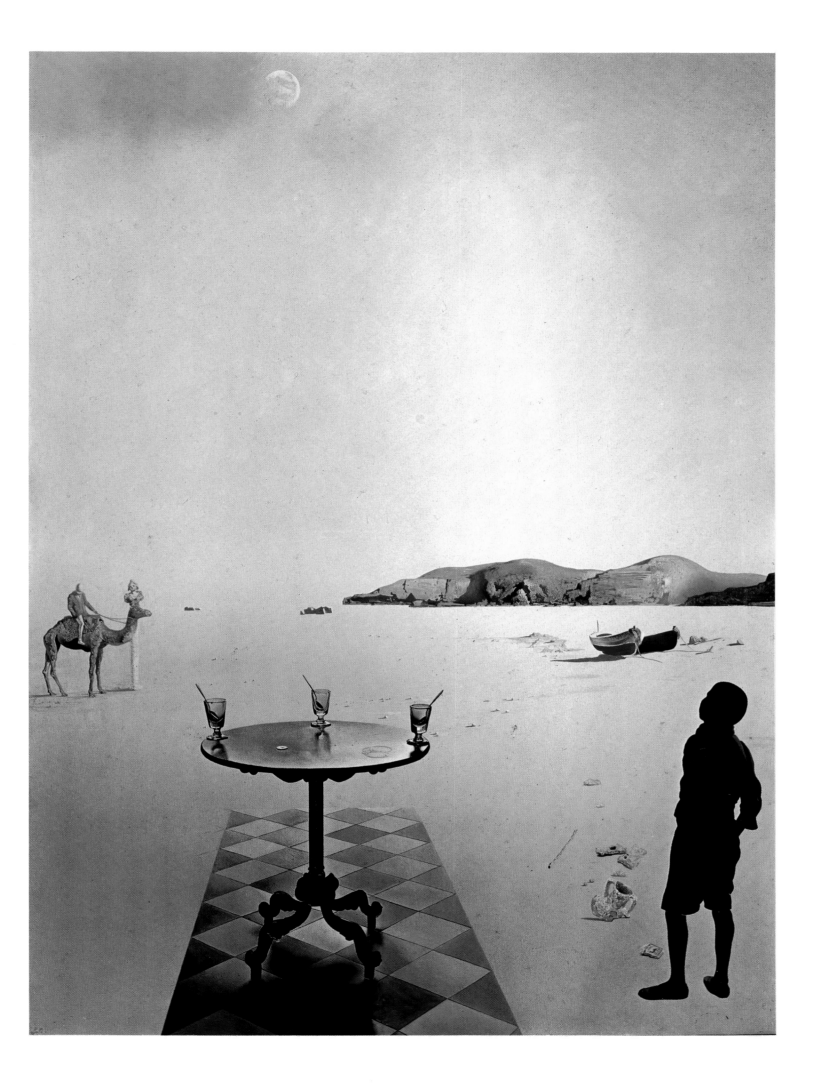

Night and Day Clothes

1936. Gouache, 11 1/4 x 15 3/4".
Private collection

Here is undoubtedly one of the most astonishing of the innumerable illustrations, pen or pencil drawings, gouaches, or watercolors produced by Dali before World War II for the most glamorous fashion magazines. This one was done during the winter of 1936 while Dali and Gala were spending a few days at Cortina d'Ampezzo. Dali thinks he remembers that it was probably destined for *Harper's Bazaar* or *Vogue*. For him, the interesting part of this creation stems from the idea that he imagined during winter sports, with snow plainly visible, an outfit that suggests sun baths, since one can easily discover four openings by rolling up a sort of shade in order to expose the body.

Most of the costumes created by Dali possess an obvious erotic power. Here, we don't know at exactly what moment the outfit becomes skin, covering, coat — indeed even a closet, cupboard, or a window — since this tunic-dress has a front zipper and can at the same time be opened wide by turning the cremone bolt which is pictured on it. Dali has always liked to associate with society people and dress designers. In a taped interview, summarized later in his *Le Journal d'un génie*, he told me apropos of his snobbism: "During the Surrealist period, it was a regular strategy. Besides René Crevel, I was the only one who associated with society people and who was accepted by them; the other Surrealists did not know this set, and were not admitted there. In front of them I could always get up quickly and say, 'I am going to a dinner party in town,' letting them imagine or speculate with whom — they would find this out the next day, and it was even better that they should learn this from intermediaries, that it had been a dinner at the Prince Faucigny Lucinge's home or at the house of people whom they looked upon as forbidden fruit since they were not received by them. Immediately afterwards, when I arrived at the houses of the society people, I practiced another type of snobbism which was much more acute; I used to say, 'I must leave very early right after the coffee, to see the Surrealist group,' which I described to them as a group that was much more difficult to enter than the aristocracy or any of the people they knew, because the Surrealists sent me insulting letters and found the society people to be 'ass-heads' who knew absolutely nothing. . . . Snobbism consists of always being able to penetrate into places to which others have no access; this gives the others an awful feeling of inferiority. . . . I must add something else: I was incapable of keeping up with all the gossip about everyone and I never knew who had quarreled with whom. Like the comedian Harry Langdon, I always appeared in places where I should not have gone. . . . But I myself, Dali, imperturbable, I used to go to the Beaumonts, then I would pay a visit to the Lopezes without knowing anything about their quarrels, or, if I did know about it, I didn't pay the least attention to it; it was the same way with Coco Chanel and Elsa Schiaparelli, who had a real civil war going in the fashion world. I used to eat lunch with the former, take tea with the latter, and in the evening dine with the first one; all this caused great waves of jealousy. I am one of those rare people who have lived in the most paradoxical circles, those most impenetrable to each other, who go in and out of them at will. I did it out of pure snobbism, that is to say because of a frenetic desire to be constantly seen in all the most inaccessible sets."

Later, the painter was to say in the course of an interview: "The constant tragedy of human life is fashion, and that is why I have always liked to collaborate with Mlle Chanel and Mme Schiaparelli, just to prove that the idea of dressing oneself, the idea of disguising oneself, was only the consequence of the traumatic experience of birth, which is the strongest of all the traumas that a human being can experience, since it is the first. Fashion is also the tragic constant of history; through it you always see war coming while watching its fashion reviews and its parades of mannequins who themselves are veritable exterminating angels."

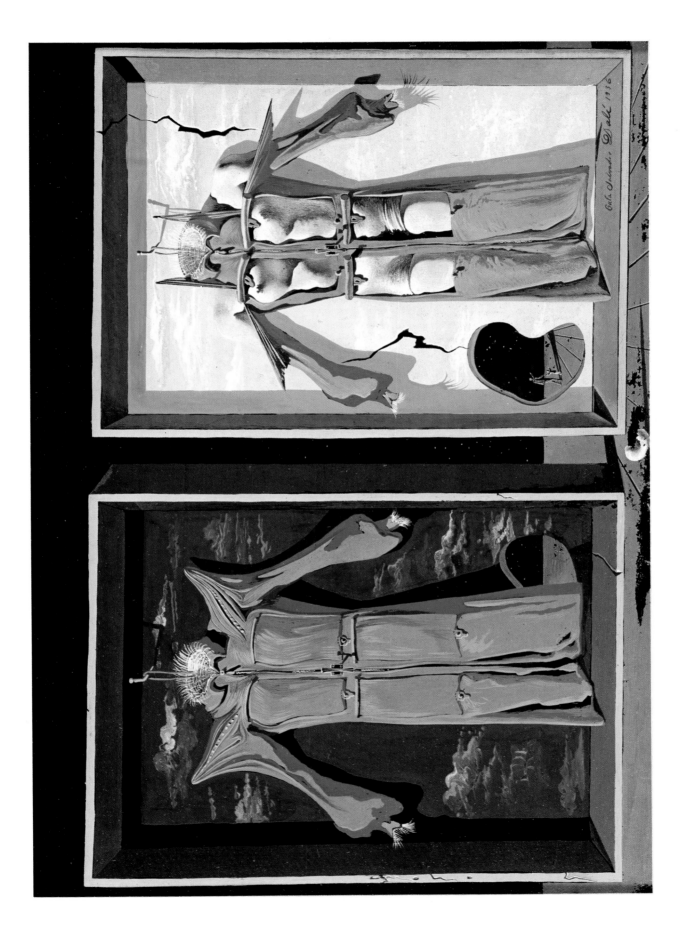

67. Study for SPAIN.
1935. Ink, 30 5/8 x 22 5/8".
Private collection

COLORPLATE 21

Spain

1936–38. *Oil on canvas, 36 1/8 x 23 5/8".*
Museum Boymans-van Beuningen, Rotterdam

The figure of the woman leaning her elbow on a night stand symbolizes the Spanish Civil War. Dali wrote in his *Secret Life:* "Throughout all martyrized Spain rose an odor of incense, of the burning flesh of priests, of spiritual quartered flesh, mixed with the powerful scent of the sweat of mobs fornicating among themselves and with Death." The torso and the face of the female figure are made up of groups of Renaissance warriors, of *condottieri,* inspired by a combat of horsemen done by Leonardo da Vinci. Although signed in 1938, this picture was probably started sooner. The other very remarkable works

of this series are *The Great Paranoiac, Paranonia, Perspectives* (fig. 35), and *Head of a Woman Having the Form of a Battle.* Dali exhibited nearly all these paintings together in a one-man show that he, aided by Gala, organized in February 1939 in the studio where the couple was living on the rue de la Tombe-Issoire in Paris. Friends and society people came to see this exhibition of paranoiac-critical activity, and Dali remembers that the first to arrive and the last to leave was Picasso, who asked especially to see *Spain.*

86

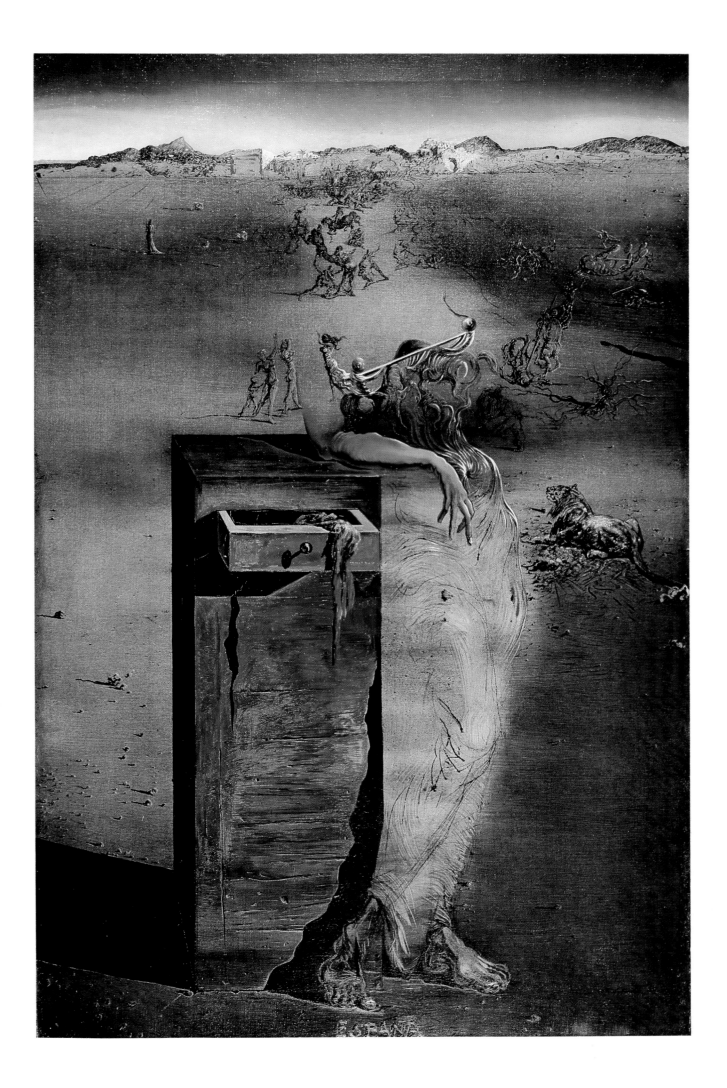

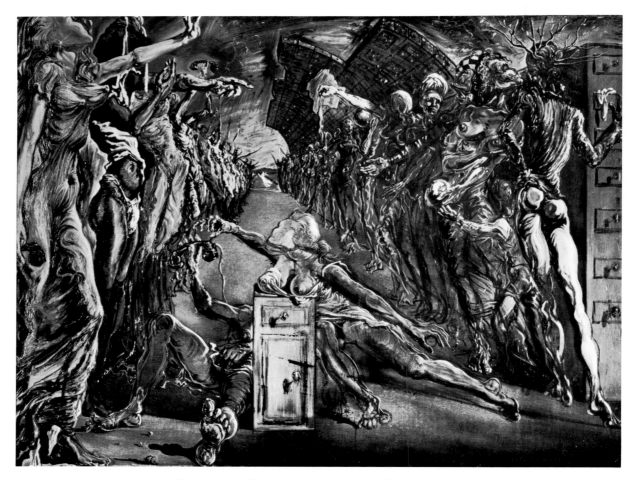

68. PALLADIO'S CORRIDOR OF DRAMATIC SURPRISE. 1938.
Oil on canvas, 29 1/2 x 41". *Private collection*

COLORPLATE 22

Palladio's Thalia Corridor

1938. Oil on canvas, 45 5/8 x 34 7/8"
Edward James Foundation, West Dean

This composition and another canvas, entitled *Palladio's Corridor of Dramatic Surprise*, were painted in Paris, rue de l'Université, after Dali and Gala had spent a long sojourn in Italy, particularly in the region of Vicenza, where the painter could see the palaces, the villas, the Olympic Theater of Vicenza, and the other buildings in the vicinity designed by the Italian genius Andrea di Pietro, called Palladio, the most important architect of the sixteenth century. One may read the following comment on these pictures in the catalogue of the Dali exhibition in 1970 at the Boymans-van Beuningen Museum: "In these paintings, named for the Italian architect Palladio, the mannerist and baroque influences are obvious: mannerism in the figures with elongated shapes, baroque in the postures, the movements, the light treated in the style of Magnasco. The proportions of the *trompe l'oeil* architectural scenery of the Olympic Theater at Vicenza have been adopted by Dali. For the scenery he has substituted rows of human figures which, by the shortened perspectives, suggest great depth." The little girl who is seen running in the sun, at the end of the corridor formed by the figures, appears several times in the pictures of the Surrealist period. Dali has explained that she was the result of two combined memories: his cousin playing with a hoop and the bell in the tower of the school in Figueras that his sister attended.

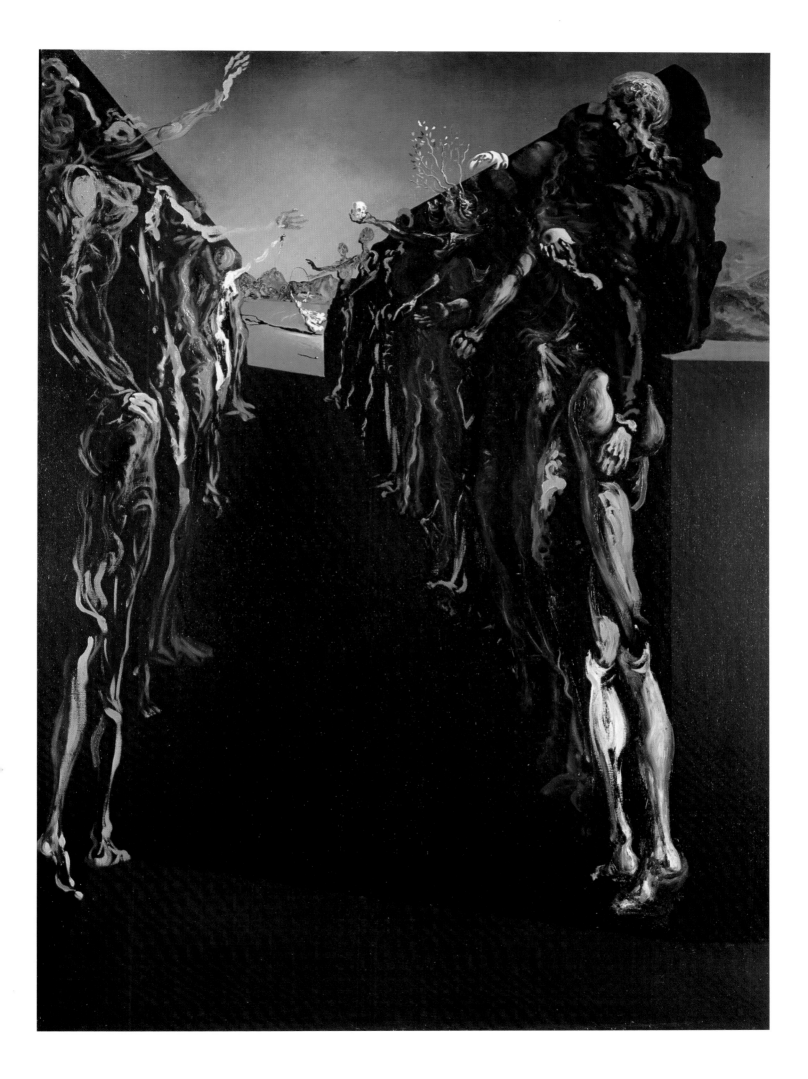

69. Salvador Dali in his studio at Coco Chanel's home in Roquebrune, 1938

70. Philosopher reclining

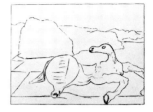

73. Mythological beast

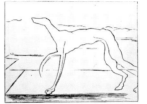

71. Greyhound

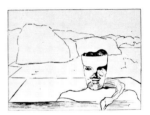

74. Face of the great Cyclopean, Cretin

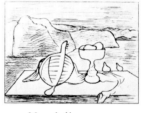

72. Mandolin, compotier, figs on a table

75. Woman seen from the back mending a sail

COLORPLATE 23

The Endless Enigma

1938. Oil on canvas, 45 x 57".
Private collection

This composition is probably the best example of paranoiac-critical activity in operation in the paintings done by Dali. He is not satisfied with pursuing a double image but succeeds in accumulating and making rise simultaneously, or one after another according to the particular capacity of the viewer, six different subjects, thus justifying the title *The Endless Enigma* which he gave to this picture.

The subjects are in succession: a reclining philosopher; a greyhound lying down; a mythological beast; the face of the great Cyclopean, Cretin; a mandolin; a compotier of fruits and figs on a table; and finally a woman seen from the back mending a sail. One can perceive here, besides, appearing in the corner at the right, the upper part of Gala's face with a turban on her head and at the bottom left, balanced on a stick, the skeletal remains of a grilled sardine. Several times during the same period Dali depicted grilled sardines, placed in dishes, together with telephones, such as: *Beach with Telephone, The Sublime Moment* (fig. 41), *Imperial Violets,* or *The Enigma of Hitler,* in all of which this instrument symbolizes the period of great political tension in Europe which preceded World War II, particularly at the time of Munich, when the telephone played such an important role in the negotiations between the Allies and Hitler. Most of these pictures, including *The Endless Enigma,* were started — indeed, almost all were painted — at the estate of Coco Chanel, "La Paula," at Roquebrune on the Côte d'Azur.

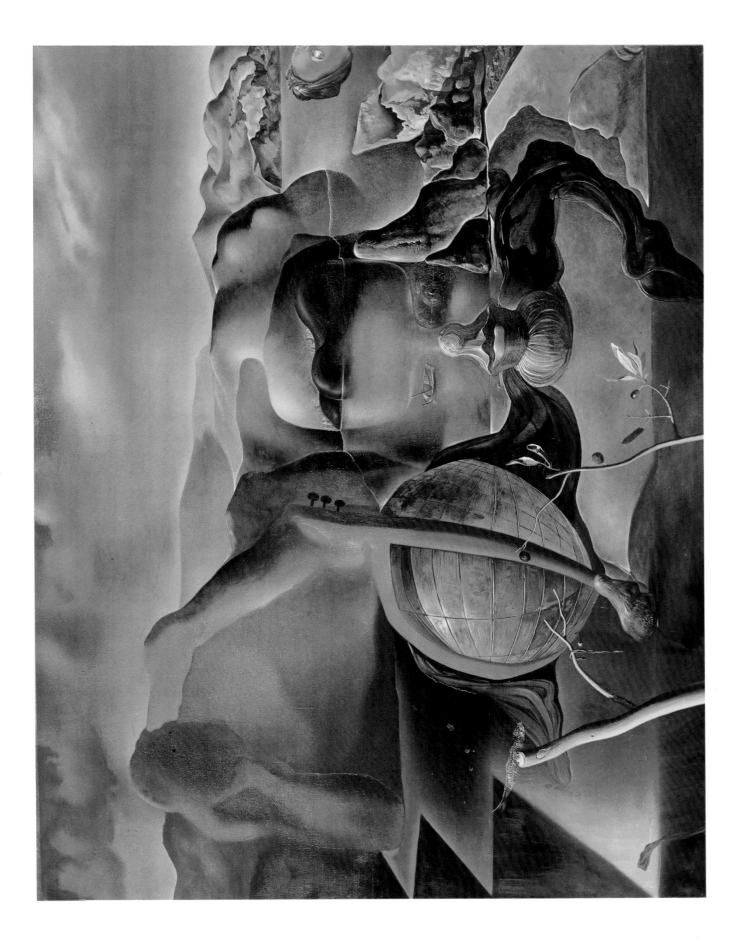

Philosopher Illuminated by the Light of the Moon and the Setting Sun

1939. Oil on canvas, 50 3/8 x 63".
Private collection

This large painting was begun shortly after Dali and Gala had left Mlle Chanel's residence on the Côte d'Azur. They were then settled in the hotel at Font-Romeu in the Pyrenees. Dali has told me that, one evening, when he was taking a walk along the coast road, he caught sight of a silhouette which exactly resembled that of General Gamelin, commander in chief of the French armies. A few days later, the hotel closed its doors and war broke out. After a few weeks spent in Paris, Dali and Gala left to live in Arcachon. The painter has stressed the fact that the light and colors in the landscapes of this period are due in large part to this region along the Atlantic where the couple spent a few months before the German invasion. By contrast, the figure in this painting is the result as much of Dali's being fed up with the Surrealists as of his regrets at not being able to return to Port Lligat because of the Civil War, which was not yet over. The reclining man is inspired by all the fishermen of Port Lligat, particularly by one named Ramón de Hermosa, whose motto was "There are years when you don't feel like doing anything at all"; he had been in this state since childhood, and his immeasurable laziness had earned him much prestige among the fishermen of Cadaqués. Dali relates that Gala had asked Ramón to pump water each evening at the well near the house to fill the washtub; she noticed at the end of the second day that there was not a drop of water in the tub, although she could hear the rhythmic noise of the pump. Dali and Gala then discovered Ramón stretched out at the foot of an olive tree in the act of cleverly imitating the grinding sound of the pump by striking two pieces of iron against each other, having taken beforehand the precaution of making the sound of his instrument perfect by suspending the two pieces of metal from two strings tied on the branches so as to expend the least effort. All the ancestral Mediterranean wisdom contained in the figures painted in this canvas shows that at bottom Dali was never profoundly influenced or completely assimilated by the Parisian Surrealist group.

By placing this painting in juxtaposition with a passage from *The Secret Life* one may better understand its meaning. "After the tense, agitated conversations in Paris, swarming with double meanings, maliciousness, and diplomacy, the stories of Ramón achieved a serenity of soul and a height of boring anecdotism which was incomparable.

"The accounts of the fishermen of Port Lligat were the same, perfectly Homeric, and of a substantial reality for my brain weary of 'wit' and of affected manners. Gala and I spent entire months without any other company than that of Lydia, her two sons, the maid, Ramón de Hermosa, and about ten fishermen who kept their boats at Port Lligat."

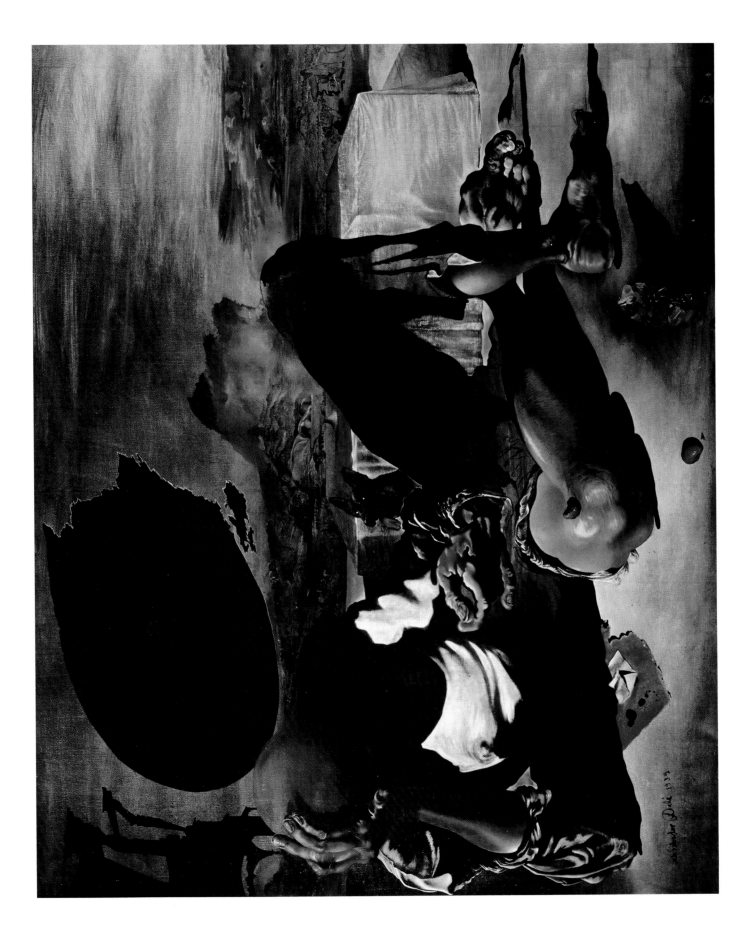

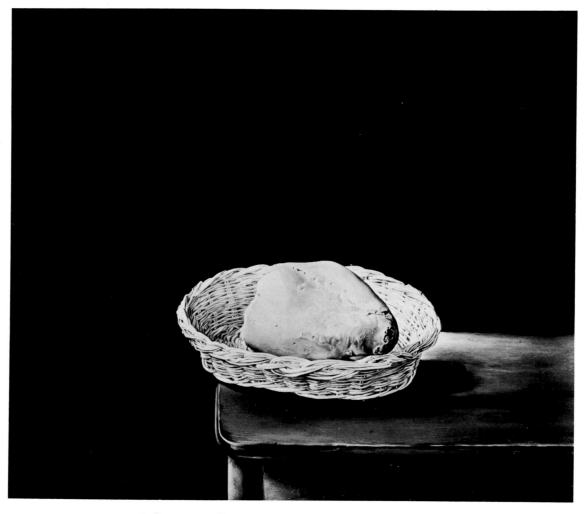

76. BASKET OF BREAD. 1945. Oil on panel, 13 x 17 3/4".
Fundación Gala-Salvador-Dali, Figueras

COLORPLATE 25

Two Pieces of Bread Expressing the Sentiment of Love

1940. *Oil on canvas*, 32 1/4 × 39 3/8".
Private collection

This beautiful still life, depicting three slices of bread, a few crumbs, and a chess pawn, is a remarkable example of the way in which Dali succeeds in adding an epic dimension to the most ordinary of everyday things. This picture was painted in Arcachon in the spring of 1940. Dali has told me about the "intervention, from an anecdotal point of view," of Marcel Duchamp in this oil: "Gala and I used to play chess every afternoon, at the same time that I was in the process of painting the slices of bread. I was trying to make the surface on which the rough crumbs of bread were placed very smooth. Often there were things scattered about on the floor, for instance, the pawns. One day, instead of putting them all back in the box, one of them remained placed in the middle of the model of my still life. Afterwards we had to find another chess set in order to continue our games, because I was using this one and

would not allow anyone to remove it." Pictures of bread occupy an important place in Dali's work, not only in painting but also in objects, such as *Retrospective Bust of a Woman*. He himself has explained the presence of bread in his works when writing about one of his paintings of 1945, *Basket of Bread* (fig. 76), in the catalogue of an exhibition at the Bignou Gallery in New York: "My aim was to retrieve the lost technique of the painters of the past, to succeed in depicting the immobility of the pre-explosive object. Bread has always been one of the oldest subjects of fetishism and obsession in my work, the first and the one to which I have remained the most faithful. I painted the same subject nineteen years ago, *The Basket of Bread* [fig. 13]. By making a very careful comparison of the two pictures, everyone can study all the history of painting right there, from the linear charm of primitivism to stereoscopic hyper-aestheticism."

94

77. VISAGE OF WAR. Study, c. 1940.
India ink, 6 5/8 x 5 1/4".
Private collection, New York

COLORPLATE 26

The Visage of War

1940. *Oil on canvas, 25 1/4 x 31".*
Museum Boymans-van Beuningen, Rotterdam

"The two most energetic motors that make the artistic and superfine brain of Salvador Dali function are, first, libido, or the sexual instinct, and, second, the anguish of death," affirms the painter; "not a single minute of my life passes without the sublime Catholic, apostolic, and Roman specter of death accompanying me even in the least important of my most subtle and capricious fantasies."

This painting was done in California at the end of the year 1940; the horrible face of war, its eyes filled with infinite death, was much more a reminiscence of the Spanish Civil War than of the Second World War, which, at the time, had not yet provided a cortege of frightful images capable of impressing Dali. He himself wrote in *The Secret Life:* "I was entering a period of rigor and asceticism which was going to dominate my style, my thoughts, and my tormented life. Spain on fire would light up this drama of the renaissance of aesthetics. Spain would serve as a holocaust to that post-war Europe tortured by ideological dramas, by moral and artistic anxieties. . . . At one fell swoop, from the middle of the Spanish cadaver, springs up, half-devoured by vermin and ideological worms, the Iberian penis in erection, huge like a cathedral filled with the white dynamite of hatred. Bury and Unbury! Disinter and Inter! In order to unbury again! Such was the charnel desire of the Civil War in that impatient Spain. One would see how she was capable of suffering; of making others suffer, of burying and unburying, of killing and resurrecting. It was necessary to scratch the earth to exhume tradition and to profane everything in order to be dazzled anew by all the treasures that the land was hiding in its entrails." The horror of this picture is further increased by the brown tonalities which dominate its atmosphere. On the anecdotal side, Dali has stressed that it was the only work where one could see the true imprint of his hand on the canvas (at the lower right).

78. SLAVE MARKET WITH DISAPPEARING BUST OF VOLTAIRE. 1940. Oil on canvas, 18 1/2 x 26".
Collection Mr. and Mrs. A. Reynolds Morse, on loan to Salvador Dali Museum, St. Petersburg, Florida

COLORPLATE 27

Invisible Bust of Voltaire

1941. Oil on canvas, 18 1/8 x 21 5/8".
Salvador Dali Museum, St. Petersburg, Florida

The concept of a still life placed in front of an architectural structure through which one glimpses a fragment of the landscape is one that Dali has made use of frequently to show to advantage the bust of Voltaire by the sculptor Houdon, which disappears to give place to a group of people. This work was done in the United States subsequently to another picture, called *Slave Market with Disappearing Bust of Voltaire* (fig. 78), painted at Arcachon in 1940, in which we find again the compotier of *The Endless Enigma* (colorplate 23) and Gala, who "by her patient love protected me from the ironic world crawling with slaves." Dali means by this that he attributes to Gala's gaze the magic power of annihilating the image of Voltaire in order to protect him from any vestige of the sceptical French philosophy of the eighteenth century and its consequences. Dali's double image of the *Bust of Voltaire* by

Houdon has been used many times in various works and publications to illustrate the time-space concept. Dali did a gouache of this figure as a picture puzzle. *Scientific American* magazine in the December 1971 issue used a detail from the *Slave Market with Disappearing Bust of Voltaire* to demonstrate the physical structure of the perception system of sight in which the optical neurons reverse the images. While painting this picture Dali related in *Dali de Gala*: "I kept reciting without ever stopping the poem of Joan Salvat Papasseit, 'Love and War, the Salt of the Earth.'" Salvat Papasseit was a Catalonian anarchist whom Dali greatly admired. In Barcelona he was accused of having become an extreme rightist because the only thing he did was to apologize for the war at a time when everybody else had become pacifists.

The Poetry of America *(unfinished)*

1943. Oil on canvas, 46 x 40".
Fundación Gala-Salvador-Dali, Figueras

This large picture was painted in a bedroom of the Del Monte Lodge in Monterey, California. Here the Dalinian doctrine has been successfully applied to transcribe the obsessive images, fruit of the years of exile Dali and Gala spent in America during World War II. American dynamism is represented by the two principal figures, football players, and by the little character posed on the appendage in the back of the one on the left; he is balancing a ball on his finger and symbolizes the physical vitality of Negroes. In this work Dali has expressed his premonition of the difficulties which would arise between the black and white citizens after the war by painting a soft map of Africa hanging from the clock in the back. As far as he is concerned the Coca-Cola bottle is also premonitory. He pointed out to me recently that he had painted the bottle with photographic meticulousness nearly twenty years before Andy Warhol and the American Pop artists started to do the same thing. They were surprised to see this canvas by the Catalonian painter dated 1943 when they thought themselves to be the first ones to show an interest in this sort of anonymous and banal object. Speaking of the vitality of the American people, Dali gave the following explanation in a taped interview in the summer of 1966: "What the American people like best is: first, blood — you have seen all the great American movies, especially the historical ones; there are always scenes where the hero is beaten in the most sadistic way in the world and where one witnesses veritable orgies of blood! Second, Americans like soft watches. Why? Because they are always looking at their watches. They are always in a hurry, terribly pressed for time, and their watches are horribly rigid, hard, and mechanical. Therefore, the day when Dali painted for the first time a soft watch, this was a great success! Because for once this awful object, which marked minute by minute the ineluctable sequence of their lives and reminded them of their urgent business, all of a sudden had become as soft as Camembert cheese when it is at its best, when it starts to run. Next, the greatest passion of the American people is when they see little children killed. Why? Because, according to the greatest psychologists in the United States, the massacre of the innocents is the favorite theme, the one which is found in the innermost depths of their subconscious minds, since they are constantly annoyed by children, so that their libido projects itself filling the cosmic surfaces of their dreams. If Americans adore bloody orgies and the slaughter of the innocents and soft watches which run like real French Camembert when it is just right, it is because what they love most in the world are 'dots,' or bits of data, those information bits that symbolize the discontinuity of matter. It is for that reason that all today's Pop art is made up of information 'dots.' "

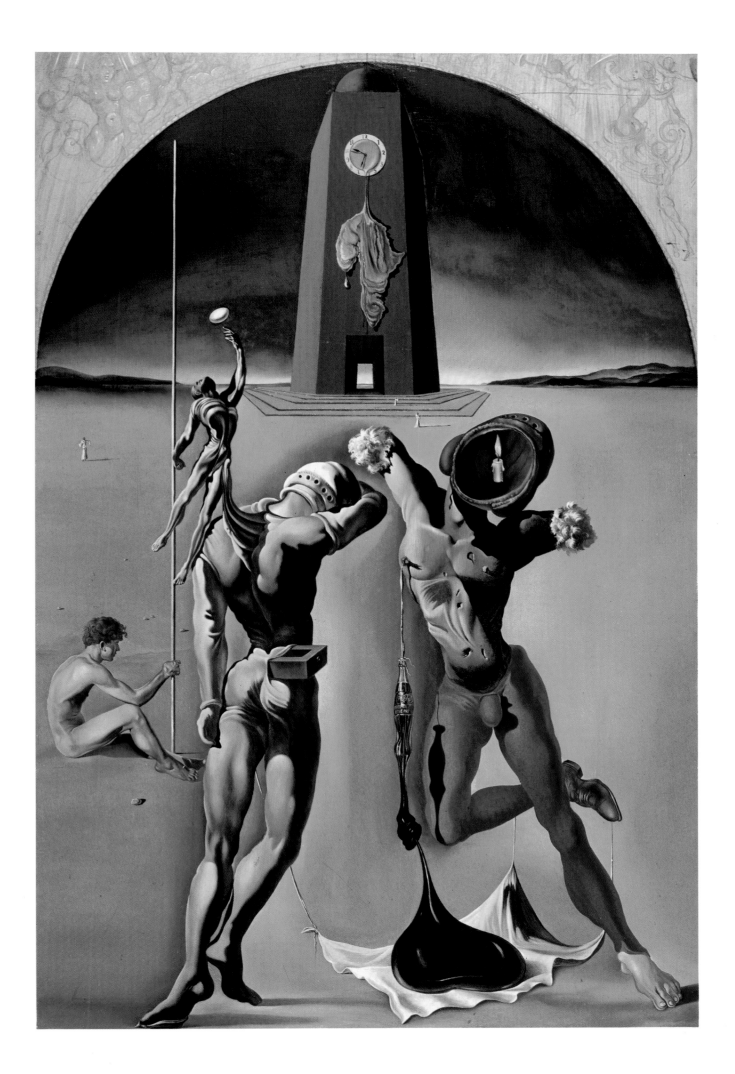

79. The True Picture of the Isle of the Dead by Arnold Böcklin at the Hour of the Angelus. 1932. Oil on panel, 30 1/2 x 25 3/8". *Von der Heydt Museum, Wuppertal*

COLORPLATE 29

Giant Flying Demi-Tasse with Incomprehensible Appendage Five Meters Long

c. 1944–45. Oil on canvas, 19 5/8 × 12 1/4".
Private collection, Basel

In this landscape, because of Dali's years of exile, the atmosphere and the light of Cadaqués have become indistinct and replaced by lighting that gives an almost abstract and very imaginary character to the rock, "La Rata" (the rat), which rises from the sea off Cape Creus. This composition was painted in New York and California right at the time when Dali was having exciting conversations with the Rumanian prince Matila Ghyka, professor of aesthetics at the University of Southern California. Dali had a thorough knowledge of his works, *The Geometry of Art and Life* and especially *The Golden Number*, an essay on the Pythagorean rites and rhythms in the development of occidental civilization, published in

1931, both of which Dali had read in Paris before the war. The entire construction of the picture hinges on the development of a rigorous logarithmic spiral whose starting point is placed on the handle of the cup. In this canvas Dali has resumed, but with a different arrangement, a theme inspired by Arnold Böcklin's *Isle of the Dead*, which he had already used in 1932, in *The True Picture of the Isle of the Dead by Arnold Böcklin at the Hour of the Angelus* (fig. 79). The painting just mentioned belonged to the Baron von der Heydt, a friend of Hitler, on whom it made a very strong impression when the Baron showed it to him.

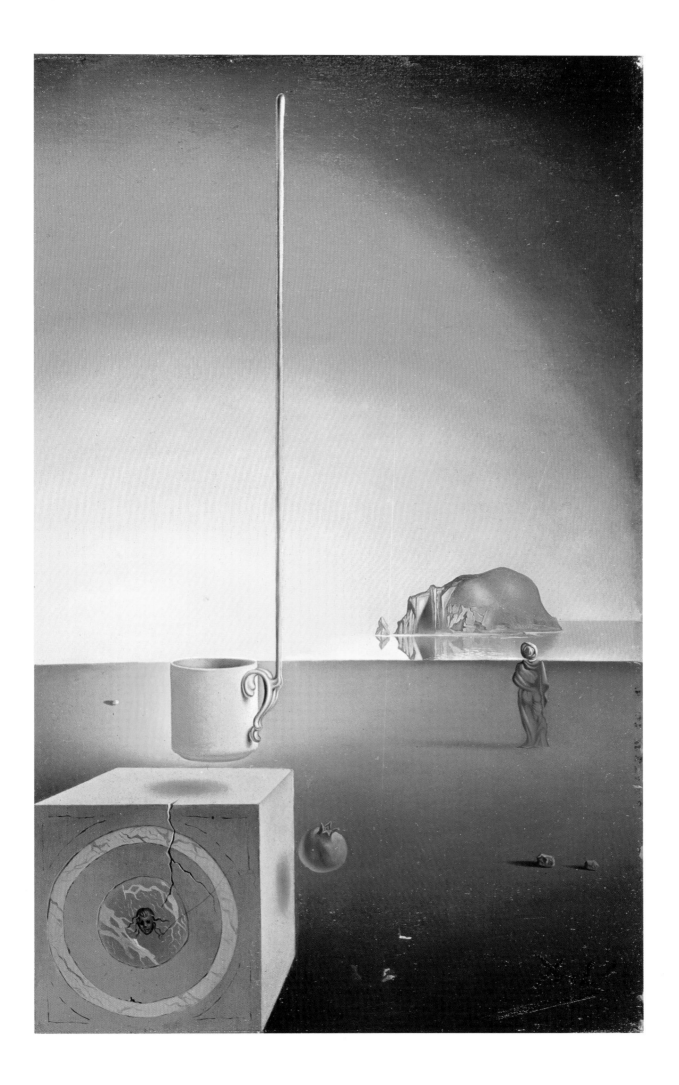

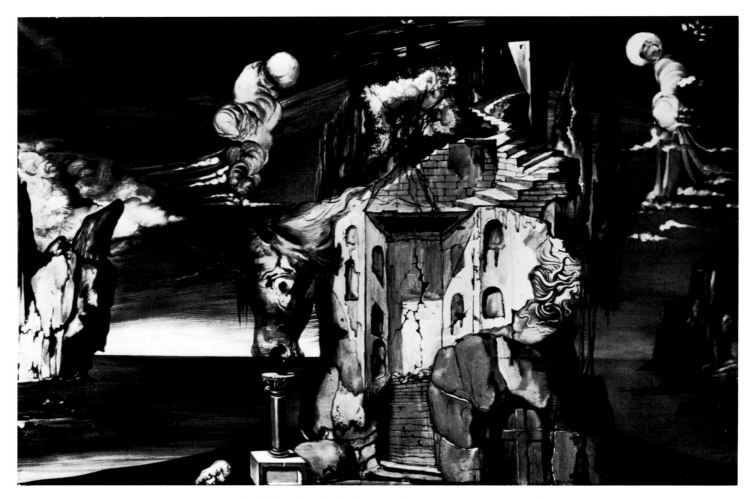

80. Backdrop for the ballet *Bacchanale*, second act. 1944.
Oil on canvas, 24 x 38". *Private collection*

COLORPLATE 30

Tristan and Isolde

1944. Oil on canvas, 10 1/2 × 19"
Private collection

The figures of Tristan and Isolde depicted on this canvas were painted by Dali in 1944 as a backdrop for the ballet *Bacchanale*, performed to Wagner's music and presented for the first time in 1944 on the stage of the International Theater in New York. The tale of this ballet, for which Dali wrote the libretto, began before the war. At that time the title was *Mad Tristan*. It was to be performed in Paris with the choreography by Léonide Massine, the scenery by Prince Charvachidze, and costumes on which Coco Chanel wished to use real ermine and genuine precious stones. The war prevented the production in Paris, and later the Marquis Georges de Cuevas decided to stage the spectacle in New York. "As with everything else," Dali writes in *The Secret Life*, "my *Mad Tristan*, which was to have been my most successful theatrical venture, could not be given; so it became *Venusberg* and finally *Bacchanale*, which is the definitive version." The ballet is favorable ground for Dali to put his paranoiac-

critical method into practice with happy results. Unfortunately, most of the time his directions were not followed exactly in the production of the scenery and staging; his ideas often seemed too difficult to execute in actual practice, they were too costly, and they could not all be accepted under the security rules normally applied to theaters.

The two latest collaborations by Dali in ballets date from 1961, when he participated with Maurice Béjart in the staging of *The Spanish Lady and the Roman Cavalier* by Scarlatti and a *Ballet de Gala* for which he wrote the libretto, designed the scenery and costumes, and demanded a curtain formed by motorcycles backfiring, hanging one from the other, and a real *boeuf-écorché-de-Rembrandt* which was to have been replaced at each performance so as to exert over the spectators the paralyzing effect of its freshness.

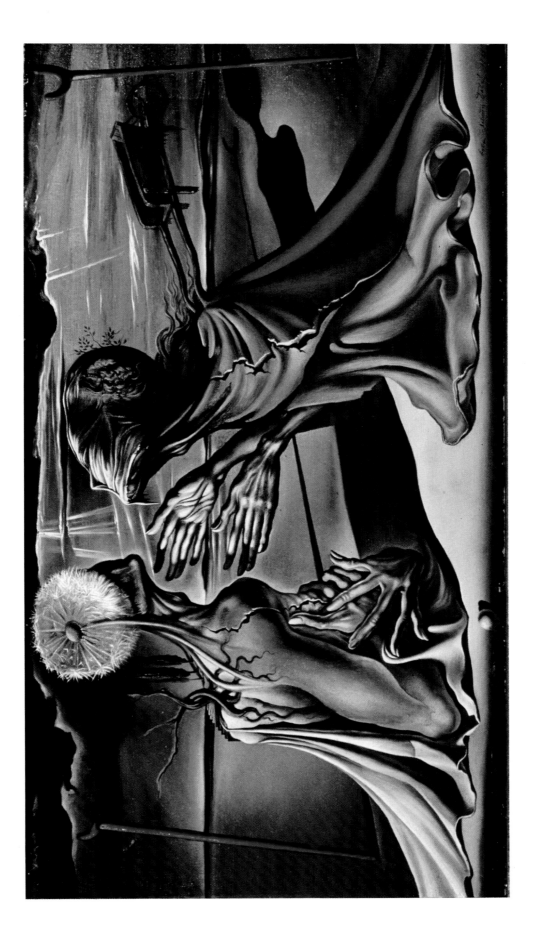

Galarina

1944–45. Oil on canvas, 26 x 20 1/8".
Fundación Gala-Salvador-Dali, Figueras

Gala has often been depicted in Dali's works. One might even say that she is the only woman whose face and silhouette appear there incessantly; the painter says, "She is the rarest being to see, the superstar who cannot in any case be compared with La Callas or Greta Garbo, because one may see them often, whereas Gala is an invisible being, the anti-exhibitionist par excellence. At Salvador Dali's home, there are two prime ministers; one is my wife, Gala, and the other is Salvador Dali. Salvador Dali and Gala are the two unique beings capable of mathematically moderating and exalting my divine madness."

This portrait belongs to the artist's classical period. It was painted in America a little before the end of the Second World War. "Started in 1944," Dali writes in the commentary of the catalogue for his exhibition in the Bignou Gallery in 1945, "it took me six months of working three hours a day to finish this portrait. I named this painting Galarina because Gala is for me what La Fornarina was to Raphael. And, without premeditation, here is the bread again. A rigorous and perspicacious analysis brings to light the resemblance of Gala's crossed arms with the sides of the basket of bread, her breast seeming to be the extremity of the crust. I had already painted Gala with two cutlets on her shoulder to transcribe the expression of my desire to devour her. It was at the time of the raw flesh of my imagination. Today, now that Gala has risen in the heraldic hierarchy of my nobility, she has become my basket of bread."

This picture was painted in the United States in 1944-45, three years after Dali had married Gala in a civil ceremony. It was being done at the moment when the artist was claiming to have discovered for the first time in his life the real way to paint; in other words, with over- and under-painting. For him, this is infinitely more subtle in its tonalities than the pictures painted before. He links it already to the period of *Leda Atomica*, when he was doing all the technical research work related to matter. This research absorbed him so much that he ended by not paying attention to conversations and even to remarks that Gala made to him. In recalling this episode he tells the following anecdote: "It was exactly during this period that I used to wake up at night to place a drop of varnish, more or less, on a painting. It was complete lunacy. Then Gala — we were in the midst of the war at the very time when the Americans were leaving for the Pacific — said to me, 'Really, what would you do if one day the same thing happened to you as to these boys who must leave for the war in airplanes every day to go and fight? It seems to me that beside this your technical problems are not so insoluble! It is much less dramatic!' And I replied, 'If they should do such a thing to me, if they insisted on leaving, on parachuting'— because at the time there was some possiblity that foreigners would be enlisted — 'well, in that case, I would not let YOU leave.' I had completely forgotten that it was a question of my going and was convinced that if anyone had to go to war, it would be Gala!"

The bracelet she is wearing on her wrist was a Fabergé creation of Mogul inspiration that Dali liked immensely. He used it placed around his wife's ankle in the painting *Original Sin*, which may be seen today in the Boymans-van Beuningen Museum in Rotterdam. The serpent, along with all of Gala's jewelry, was stolen a few years later from the bedroom of the hotel in which the couple was staying in California.

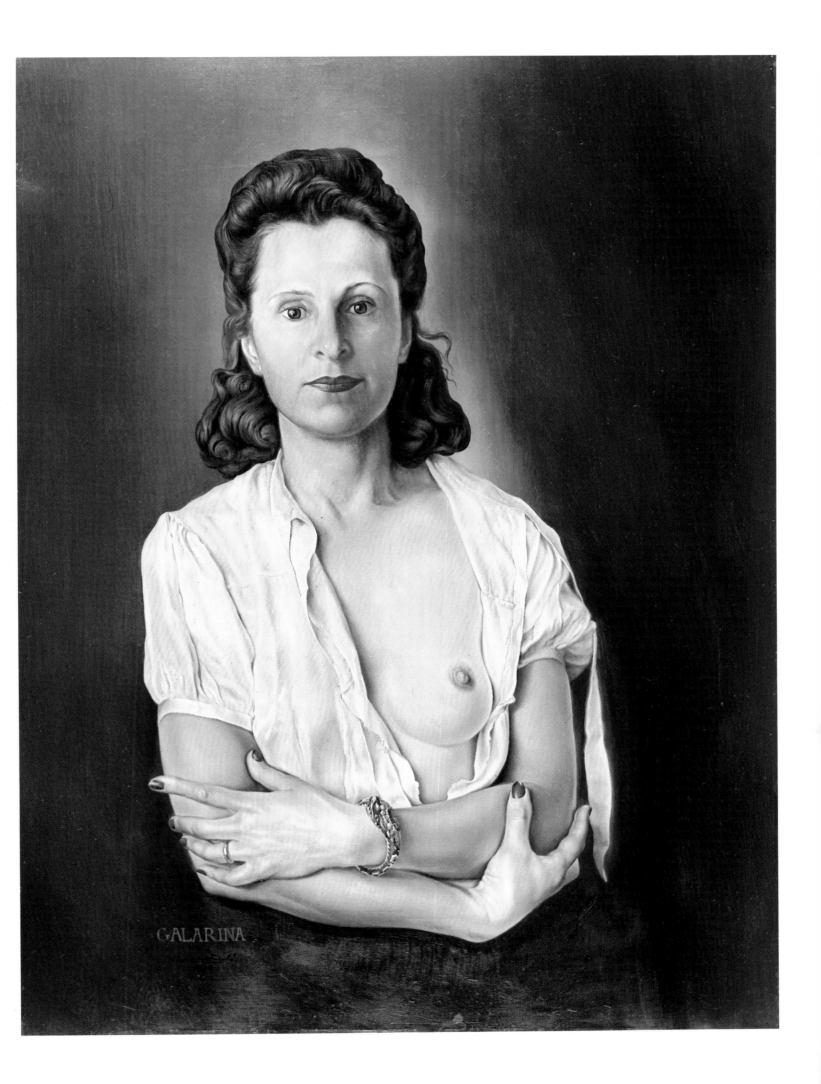

COLORPLATE 32

The Temptation of Saint Anthony

1946. Oil on canvas, 35 1/4 × 47"
Musées Royaux des Beaux-Arts de Belgique, Brussels

In this picture temptation appears to Saint Anthony successively in the form of a horse in the foreground representing strength, sometimes also the symbol of voluptuousness, and in the form of the elephant which follows it, carrying on its back the golden cup of lust in which a nude woman is standing precariously balanced on the fragile pedestal, a figure which emphasizes the erotic character of the composition. The other elephants are carrying buildings on their backs; the first of these is an obelisk inspired by that of Bernini in Rome, the second and third are burdened with Venetian edifices in the style of Palladio. In the background another elephant carries a tall tower which is not without phallic overtones, and in the clouds one can glimpse a few fragments of the Escorial, symbol of temporal and spiritual order. The elephant theme appears several times in Dali's works of this period: for example, in *Atomica Melancholica*

(fig. 43) of 1945 and *Triumph of Dionysus* of 1953.

This picture was painted in the studio that the artist occupied for a few days next to the Colony Restaurant in New York. It is the first and only time that he participated in a contest. It was an invitational artistic competition for a painting on the theme of the temptation of Saint Anthony, organized in 1946 by the Loew Lewin Company, a movie-producing firm. The winning picture was to figure in a film taken from the story "Bel Ami" by Maupassant. Eleven painters took part in the competition, among them Leonora Carrington, Dali, Paul Delvaux, Max Ernst, and Dorothea Tanning. The prize was given to Max Ernst by a jury composed of Alfred Barr, Marcel Duchamp, and Sidney Janis. All these works were shown at an exhibition in Brussels and in Rome during 1947.

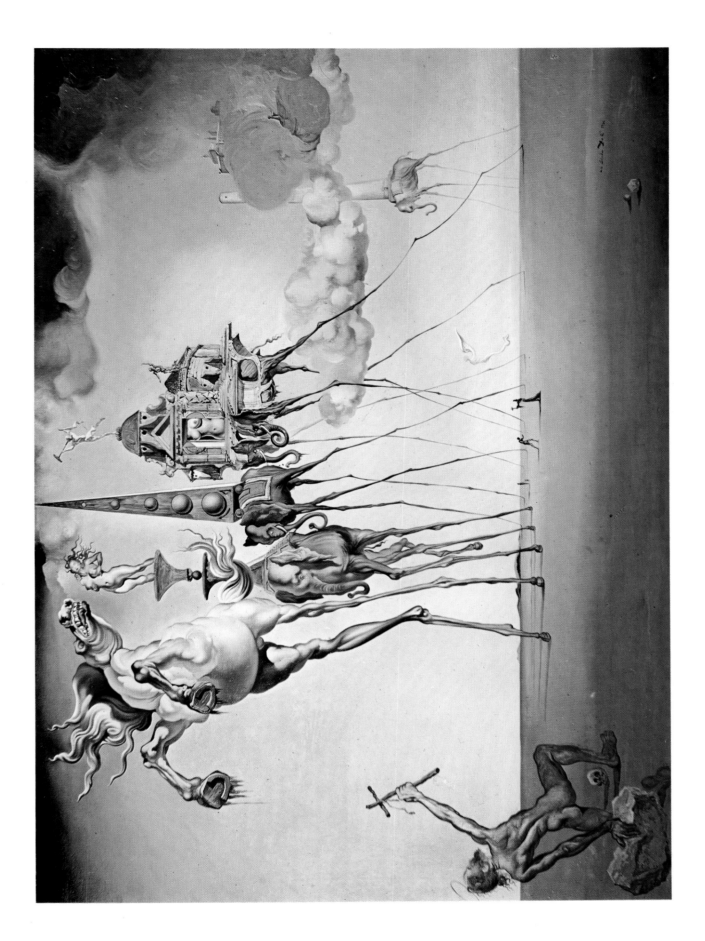

82. SOFT SELF-PORTRAIT WITH
GRILLED BACON. 1941.
Oil on canvas, 24 1/8 x 20".
Fundación Gala-Salvador-Dali,
Figueras

COLORPLATE 33

Portrait of Picasso

1947. Oil on canvas, 25 1/4 x 21 1/2".
Fundación Gala-Salvador-Dali, Figueras

Dali painted the portrait of his genial compatriot in California. It is interesting to compare it with his own *Soft Self-Portrait with Grilled Bacon*, painted six years earlier in the same place.

This portrait might be entitled *Official Paranoiac Portrait of Pablo Picasso*, because Dali has assembled here all the folkloric elements that anecdotally depict the origins of the Andalusian painter. His renown is affirmed by his bust mounted on a pedestal, symbol of official consecration; the breasts depict Picasso's nutritious aspect while he carries on his head the heavy rock of the responsibility for the influence of his work on contemporary painting. The face itself is a mixture of a goat hoof and the headdress of the Greco-Iberian marble bust, the *Lady of Elche*, which brings to mind the Andalusian and Malagan origins of Picasso. The Iberian folklore is finished off with a carnation, a jasmine flower, and the guitar. Speaking about the work of this Titan shortly after his death, Dali said: "I believe that the magic in Picasso's work is romantic, in other words, the root of its upheaval, while mine can only be done by building on tradition. I am totally different from Picasso, since he was not interested in beauty, but in ugliness and I, more and more, in beauty; but ugly beauty and beautiful beauty, in extreme cases of geniuses like Picasso and me, can be of an angelic type."

83. THE MADONNA OF PORT LLIGAT
(entire work)

COLORPLATE 34

The Madonna of Port Lligat *(detail)*

1950. Oil on canvas, 12 × 8'.
Collection Lady Beaverbrook, New Brunswick, Canada

This immense canvas, one of Dali's most famous, marks the beginning of a new period in his work. At the same time, it is the first picture so large, it is the first of the religious paintings, and it heralds the corpuscular epoch. The whole composition is arranged around the eucharistic bread visible through a hole in the center of Jesus' body, the point of intersection of the diagonal lines indicating the middle of the painting. Gala is depicted as the Virgin and also as the cuttlefish-angels on the right side of the canvas. A little boy of Cadaqués called Juan Figueras was used as the model for the infant Jesus.

"*Gala Madonna* embodies all the geological virtues of Port Lligat," the painter wrote in 1956; "for example, the nurse, from whose back the night stand was taken, has this time been sublimated into the tabernacle of living flesh through which the celestial sky may be seen, and in turn another tabernacle cut from the chest of the infant Jesus, containing eucharistic bread in suspension." There are two oils of the same subject; that reproduced here is the second one. The first, which is smaller in size, was submitted by Dali to Pope Pius XII for approval and is now at Marquette University. About

the larger canvas, Dali has commented to me: "This picture because of its size was destined to know many mishaps. In the midst of an awful storm we had to have a contractor come to Port Lligat to enlarge the window in the room, the room with the birds, because the canvas on its stretcher would not go through the window. Then Gala had to hire a truck, because it was too big for the train, to ship it first to Paris and then to Le Havre, in order to ship it by boat to America. In New York, it was too big for any elevator; they had to hoist it up with a rope to the windows of the floor on which the Carstairs Gallery was located and where it was to be shown. The dealer, George Keller, himself said at the time, 'This painting is magnificent, but I will never be able to sell it, because there is no house big enough for it, and it costs to much to ship it around.' It is, however, the one which opened the doors to the sale of all my large pictures." Today *The Madonna of Port Lligat* is in the collection of Lady Beaverbrook in Canada. It is never shown in retrospective exhibitions because, in order to get it out, it would be necessary to knock down the door or take out one of the windows in the library where it hangs.

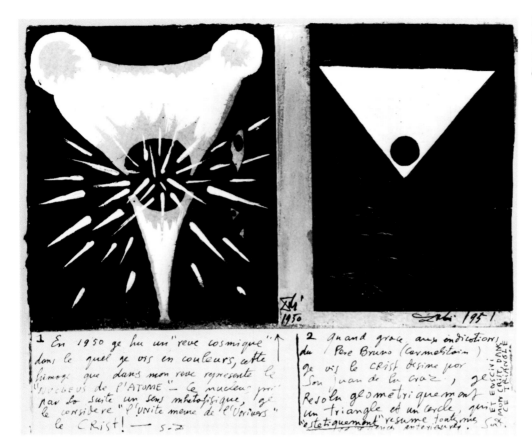

84. Study for CHRIST OF
SAINT JOHN OF THE CROSS.
1950-51. Gouache, 6 3/4 x 8".
Collection T. J. Honeyman, Glasgow

COLORPLATE 35

Christh of Saint John of the Cross

1951. *Oil on canvas*, 81 × 45 5/8".
Glasgow Art Gallery and Museum

By far the most popular of all Dali's religious works is without a doubt his *Christ of Saint John of the Cross*, whose figure dominates the Bay of Port Lligat. The painting was inspired by a drawing, preserved in the Convent of the Incarnation in Avila, Spain, and done by Saint John of the Cross himself after he had seen this vision of Christ during an ecstasy. The people beside the boat are derived from a picture by Le Nain and from a drawing by Velázquez for *The Surrender of Breda*. At the bottom of his studies for the Christ, Dali wrote: "In the first place, in 1950, I had a 'cosmic dream' in which I saw this image in color and which in my dream represented the 'nucleus of the atom.' This nucleus later took on a metaphysical sense; I considered it 'the very unity of the universe,' the Christ! In the second place, when, thanks to the instructions of Father Bruno, a Carmelite, I saw the Christ drawn by Saint John of the Cross, I worked out geometrically a triangle and a circle, which 'aesthetically' summarized all my previous experiments, and I inscribed my Christ in this triangle." This work was regarded as banal by an important art critic when it was first exhibited in London. Nevertheless,

several years later, it was slashed by a fanatic while it was hanging in the Glasgow Museum, proof of its astonishing effect on people. Dali relates that, when he was finishing the picture at the end of autumn in 1951, it was so cold in the house in Port Lligat that Gala abruptly decided to have central heating installed. He remembers the moments of terror through which he then lived, fearing for his canvas on which the paint was still wet, with all the dust stirred up by the workmen: "We took it from the studio to the bedroom so that I could continue to paint, covered with a white sheet which dare not touch the surface of the oil. I said that I didn't believe I could do my Christ again if any accident were to befall it. It was true ceremonial anguish. In ten days the central heating was installed and I was able to finish the picture in order to take it to London, where it was shown for the first time at the Lefevre Gallery." When it was at the Biennial of Art in Madrid, along with other works of the painter, General Franco asked that two of the oils of the master of Figueras be brought to the palace of El Prado — *Basket of Bread* (fig. 76) and *Christ of Saint John of the Cross*.

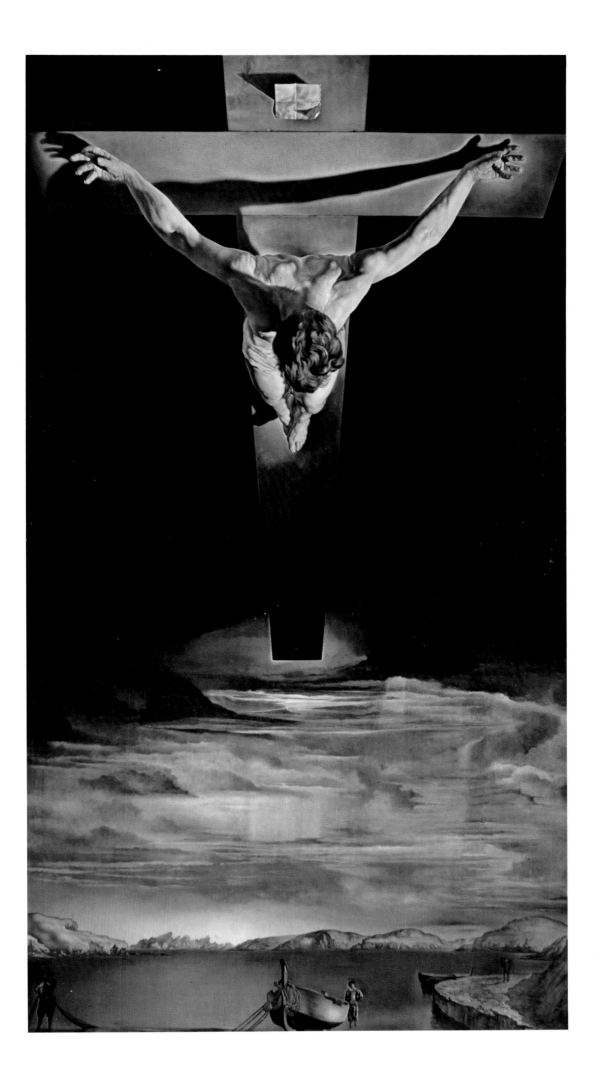

COLORPLATE 36

Rhinocerotic Figure of Phidias' Illisos

1954. *Oil on canvas, 39 3/8 × 51".*
Private collection

Painted during Dali's corpuscular period, this is one of the pictures in which the artist used rhinoceros' horns in suspension to form a part or the entire figure of his subject, as in *Raphaelesque Head Exploding* of 1951 (fig. 44), *Paranoiac-Critical Study of Vermeer's Lacemaker* (fig. 85) of 1954-55, or *Young Virgin Auto-Sodomized by Her Own Chastity* (fig. 46). The *Illisos* was begun in Port Lligat during the summer of 1953 at the same time that Dali was working on the *Crucifixon (Corpus Hypercubus)*, now in the Metropolitan Museum in New York (colorplate 37). In his *Le Journal d'un génie*, Dali has given a detailed account of his day-to-day progress on these two works, describing how he managed to overcome his fear of undertaking certain surfaces of the canvas, which seemed to come from his neurotic fear of not having any testicles and of always keeping his teeth too tightly clenched. He conquered this fear one afternoon by attacking two completely different things: the torso and the testicles of Illisos. The care he devoted every day to this picture must be regarded as the strenuous work of a painter who knows how to seek mastery by doing a still life at the same time that he controls the atmosphere and the rendering of a work of his imagination, such as *Crucifixion (Corpus Hypercubus)*. As a respite from the tension demanded by his work on the *Crucifixion*, he did the *Illisos* in his studio, using as a model a plaster replica of this marvelous sculpture by Phidias, originally found on the west pediment of the Parthenon and today in the British Museum in London.

The mythological figure is depicted in suspension in the middle of the Bay of Cadaqués, where one glimpses in the background the rock called Cucurucuc which stands at the entrance to the bay. The underpart of the water is treated the same as in two other paintings, the first one dated 1950 and entitled *Dali at the Age of Six When He Believed Himself to Be a Young Girl, Lifting with Extreme Precaution the Skin of the Water to Observe a Dog Sleeping in the Shadow of the Sea*, and the second from 1963: *Hercules Lifts the Skin of the Sea and Stops Venus for an Instant from Waking Love*.

116

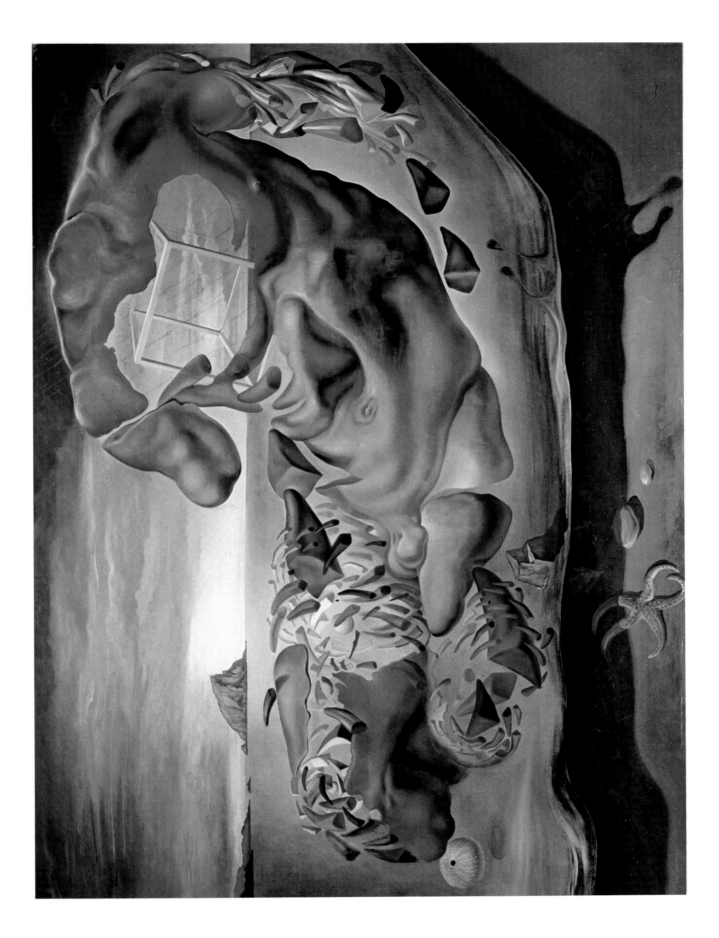

86. NUCLEAR CROSS. 1952.
Oil on canvas, 30 3/4 x 22 7/8".
Private collection

COLORPLATE 37

Crucifixion (Corpus Hypercubus)

1954. Oil on canvas, 76 3/8 × 48 7/8".
Metropolitan Museum of Art, New York. Gift of Chester Dale, 1955

When disembarking from the steamship *America* in Le Havre on March 27, 1953, on his return from New York, Dali announced to the reporters gathered around him that he was going to paint a picture which he himself termed as sensational: an exploding Christ, nuclear and hypercubic. He said that it would be the first picture painted with a classical technique and an academic formula but actually composed of cubic elements. To a reporter who asked him why he wanted to depict Christ exploding, he replied, "I don't know yet. First I have ideas, I explain them later. This picture will be the great metaphysical work of my summer."

It was at the end of spring in 1953 in Port Lligat that Dali began this work, but it is dated 1954, the year in which it was finished and then exhibited in the month of December at the Carstairs Gallery in New York. The painting may be regarded as one of the most significant of his religious oils in the classical style, along with *The Madonna of Port Lligat, Christ of Saint John of the Cross* (colorplates 34 and 35), and *The Last Supper,* which is in the National Gallery in Washington, D. C.

"Metaphysical, transcendent cubism" is the way that Dali defines his picture, of which he says: "It is based entirely on the *Treatise on Cubic Form* by Juan de Herrera, Philip II's architect, builder of the Escorial Palace; it is a treatise inspired by *Ars Magna* of the Catalonian philosopher and alchemist, Raymond Lulle. The cross is formed by an octahedral hypercube. The number nine is identifiable and becomes especially consubstantial with the body of Christ. The extremely noble figure of Gala is the perfect union of the development of the hypercubic octahedron on the human level of the cube. She is depicted in front of the Bay of Port Lligat. The most noble beings were painted by Velázquez and Zurbarán; I only approach nobility while painting Gala, and nobility can only be inspired by the human being."

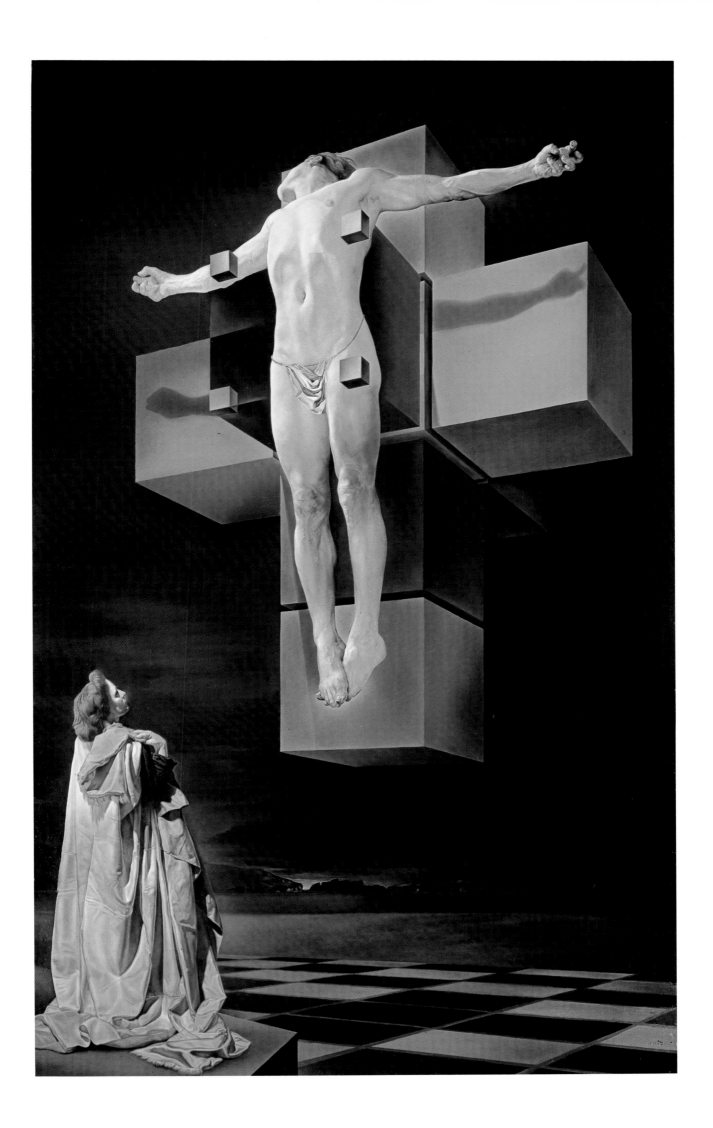

COLORPLATE 38

The Discovery of America by Christopher Columbus

*1959. Oil on canvas, 13' 6" x 9'4".
Morse Charitable Trust, on loan to Salvador Dali Museum, St. Petersburg, Florida*

From the first day that he set foot on the pavement of Surrealist Paris, Dali has never ceased to proclaim that most of the *pompiers* painters and the ultra-academicians, especially Meissonier and the Spanish Mariano Fortuny, were a thousand times more interesting than the representatives of all the aging "isms" of modern art, and the African, Polynesian, Indian, and even Chinese art objects. Therefore, it was normal that, at a certain point in his life, he should come face to face with patriotism, and, as the *pompiers* did at the end of the nineteenth century, he decided to paint pictures glorifying the history of his country.

The Discovery of America by Christopher Columbus was painted in 1958 and 1959. This oil antedated *Santiago el Grande*, which depicts Saint James of Compostela, patron saint of Spain. Dali says that in this canvas he painted for the first time with an existentialist shiver: the shiver for the unity of the fatherland. Everything in it springs from the four petals of a jasmine flower exploding in an atomic cloud of creative genius. Two years after finishing his *Discovery of America*, Dali produced a third historical work, *The Battle of Tetuán* (fig. 51), inspired by Mariano Fortuny's painting of the same name which is in the Museum of Modern Art in Barcelona. *The Discovery of America by Christopher*

Columbus was a major step in Dali's painting of that period. Here one finds for the first time, brought together and intimately mixed with previous styles, the technique of his corpuscular period. In this canvas, the figure on the banner is Gala, and the monk kneeling and holding the crucifix is Dali. In a taped interview in 1972, while speaking about this picture he told me that he had wished to pay homage to the glory of Velázquez. On the other hand, what seemed to him more important from a technical point of view was to employ a process utilizing the lines of the photoengraver which, greatly enlarged, would allow the image, taken from the *Christ* of Glasgow, to reappear so that it would seem to mingle with the glorious halberds of the Spanish warriors, inspired by the painting by Velázquez in the Prado Museum, *The Surrender of Breda*.

It may seem surprising to say that Dali decided to paint pictures glorifying *his* country and then show Columbus discovering America. However, it has been argued that Columbus was a Spaniard. He never wrote anything in Italian; all his writings are in Spanish, and some historians believe that his family was forced to leave Spain and flee to Italy. The Catalonians firmly believe that he was from Catalonia. Therefore, to Dali, this was the logical beginning of his historical paintings.

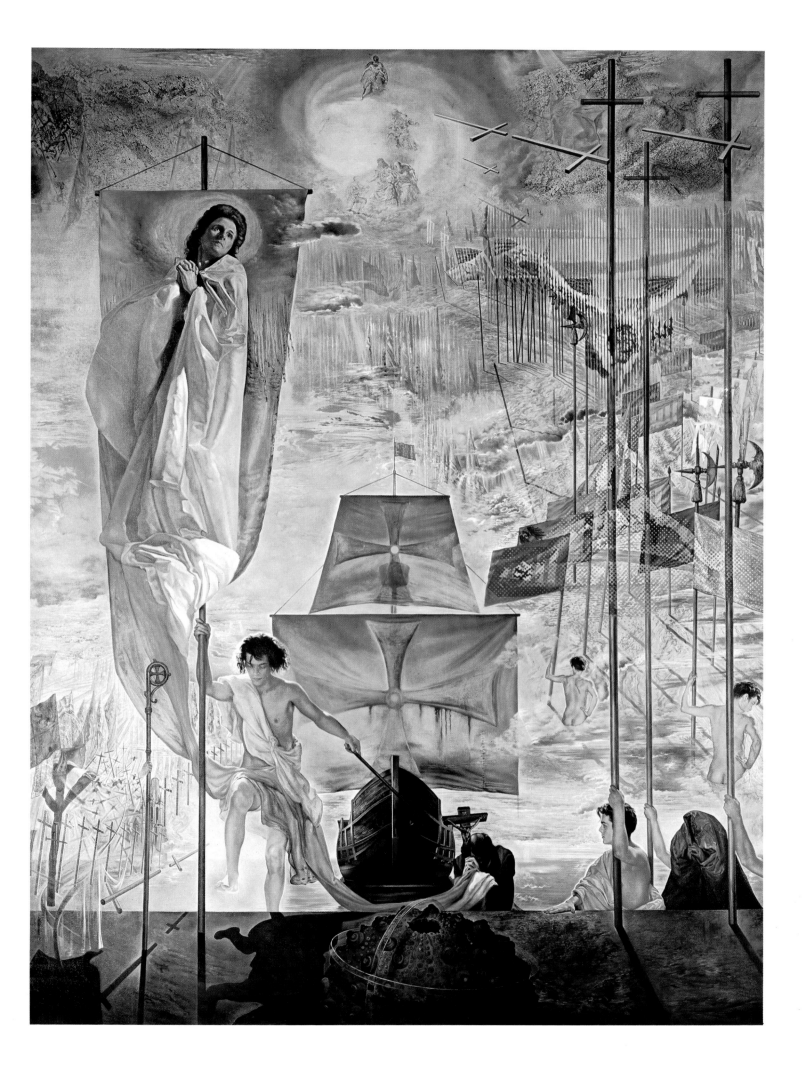

88. VENUS DE MILO WITH DRAWERS. 1936. Plaster,
38 5/8 x 12 3/4 x 13 3/8". *Private collection*

COLORPLATE 39

The Hallucinogenic Toreador

1968-70. *Oil on canvas, 13' 1" x 12'7".*
Morse Charitable Trust, on loan to Salvador Dali Museum, St. Petersburg, Florida

This large vertical composition was begun in Port Lligat in 1968 and finished in 1970, when it was purchased by Mr. and Mrs. A. Reynolds Morse for The Salvador Dali Museum in Cleveland, to be hung along with their other works already assembled there.

The double image appearing in the center of this work is that of the *Venus de Milo* repeated several times from different angles in such a way that the shadows form the features of a toreador whose coat of lights is made up of the corpuscles obtained through the multiplication of dots and of flies, mingled with the corpuscular image of the dying bull. Dali's first obsession with the Venus de Milo was in 1936, when he transformed a plaster replica into *Venus de Milo with Drawers*, putting drawers

in her body and in her forehead. He told me recently that he had practically not touched the original plaster, on which he had only marked where the drawers should be. It was Marcel Duchamp, creator of the ready-made, who undertook the production of the model.

Here, it was in the Venus de Milo reproduced on the cover of a box of pencils of a well-known brand that Dali instantly saw the face of a toreador appear. The architecture of the arena lighted by the shadows of the sun at five o'clock in the afternoon, the hour of the bullfight, is a mixture of classical Spanish arenas with Palladian structures seen in Italy and the porticoes in the old, ruined theater in Figueras before it was transformed into the Teatro-Museo Dali.

122

Dali from the Back Painting Gala from the Back Eternized by Six Virtual Corneas Provisionally Reflected by Six Real Mirrors *(unfinished)*

1972-73. Oil on canvas, 23 5/8 x 23 5/8".
Fundación Gala-Salvador-Dali, Figueras

Research into the third dimension, completely controlled by the rigorous laws of perspective, plays a dominant role in the work of Salvador Dali. The painter has always been interested in methods of depicting spatial dimensions, the offshoot of optics and photography: stereoscopy, holography, stereo-video. "In the pictorial domain," he has written, "my sole ambitions were directed toward optical truth, even before arriving in Paris. I have always praised color photography." The extreme precision with which he paints his subjects, copied according to his needs just as expertly from photographs as from nature — his talent allows this — makes him define painting in this way. "Photography in three dimensions and in color of the superfine images of concrete irrationality, entirely made by hand." Since 1961, when Dali was studying stereoscopy, I have been able to collaborate directly with him in all his research work. In 1971 he came upon the work of the Dutch painter Gerard Dou, and he noticed that several paintings by this pupil of Rembrandt, done in two versions, exhibited undeniable stereoscopic characteristics. He then decided to return to the experiments of Dou: starting with stereoscopic documents, he painted two canvases, one for the left eye, the other for the right eye.

These appeared to be in three dimensions, with the help of a system of mirrors focused by Roger de Montebello. The first images were disappointing, the major disadvantage being the weight of the glass, its fragility, and the impossibility of getting rid of the reflected double image caused by the thickness of the glass mirrors. I was able to solve this problem, to Dali's great satisfaction, by using tightly stretched plastic film with a higher power of refraction than glass. Thanks to these new methods, stereoscopy ceased being a secret and became monumental. Going further, going beyond painting, in December 1973 I suggested that Dali apply our discovery to television, creating a stereo-video in which experimentation continues.

This colorplate shows the painting for the right eye faithfully copied by Dali from the stereoscopic photograph in black and white. All the painter's work turned toward the study of the variations of colors, values, and the rendering of the lights and shadows from one canvas to the other in order to achieve a three-dimensional effect and to offer a new stereoscopic, binocular vision, thanks to the optical superimposing of his two paintings.

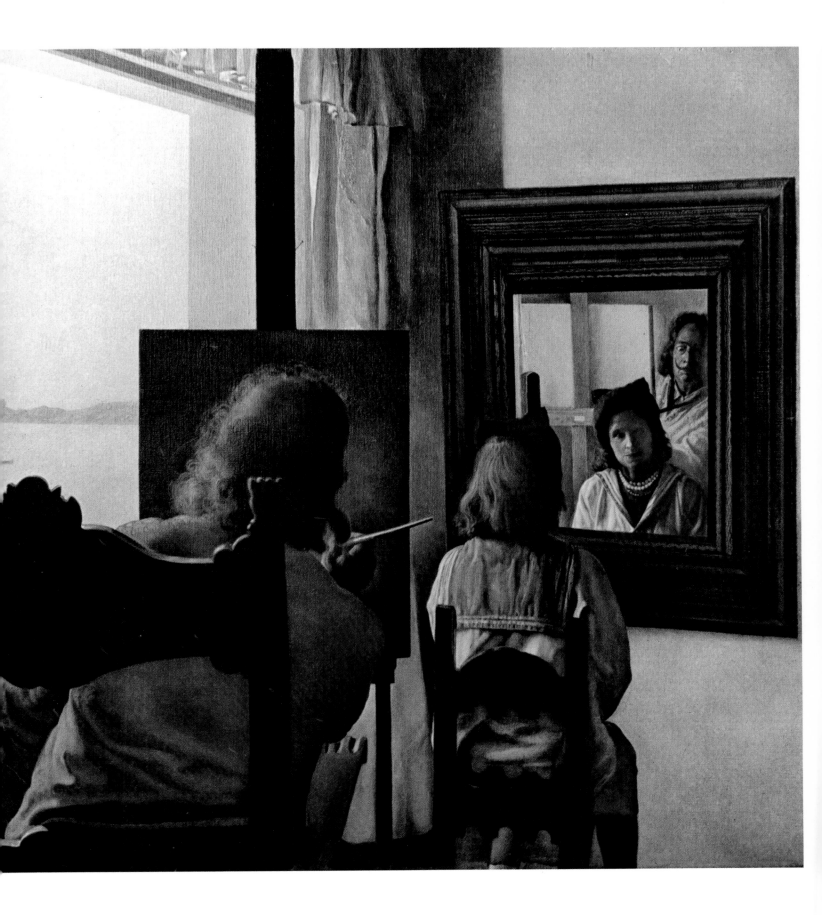

SELECTED BIBLIOGRAPHY

WRITINGS ON DALI

Alexandrian, Sarane. *Dali illustré.* Vol. 1, 1930–40. Collection Le Monde des Grands Musées. Paris: Filipacchi, 1974.

Arco, Manuel del, ed. *Dali al desnudo.* Barcelona: José Janés, 1952.

Baden-Baden, Staatliche Kunsthalle. *Dali: Gemälde, Zeichnungen, Objekte, Schmuck.* Exhibition catalogue; including the Edward F. W. James collection. Baden-Baden: 1971 (in French and German).

Bosquet, Alain. *Conversations with Dali.* New York: Dutton, 1969.

Cowles, Fleur. *The Case of Salvador Dali.* London: William Heinemann, Ltd., 1959.

Crevel, René. *Dali; ou l'anti-obscurantisme.* Paris: Editions Surréalistes, 1931.

Dali, Ana-María. *Salvador Dali, visto por su hermana.* Barcelona: Editorial Juventud, 1949.

Descharnes, Robert. *Dali de Gala.* Lausanne: Edita, 1962.

———. *The World of Salvador Dali.* New York: Harper and Row, 1962.

———, and Tadao Ogura. *Salvador Dali.* Collection L'Art du Monde, vol. 25. Tokyo: Shuei-Sha, 1974.

Frankfurt am Main, Städtische Galerie und Städelsches Kunstinstitut. *Salvador Dali.* Exhibition catalogue. Frankfurt am Main: 1974.

Gaya Nuño, Juan Antonio. *Salvador Dali.* Barcelona: Ediciones Omega, 1950.

Gérard, Max, ed. *Dali.* New York: Harry N. Abrams, 1968.

———. *Dali . . . Dali . . . Dali . . .* Preface by Dr. Pierre Roumeguère. New York: Harry N. Abrams, 1974.

Lake, Carlton. *In Quest of Dali.* New York: Putnam, 1969.

Livingston, Lida, ed. *Dali: a Study of His Art-in-Jewels.* The Collection of the Owen Cheatham Foundation. Boston: New York Graphic Society, 1959.

———. *Salvador Dali, A Catalog of His Works in Public Museum Collections.* Cleveland: The Salvador Dali Museum, 1974.

Longstreet, Stephen. *The Drawings of Dali.* Los Angeles: Borden Publishing Co., 1964.

Morse, A. Reynolds. *A Catalogue of Works by Salvador Dali in Public Museum Collections.* Cleveland: Reynolds Morse Foundation, 1956.

———. *Dali: a Study of His Life and Works.* Boston New York Graphic Society, 1958.

———. *A Documentation of Dali Source Material in the Vicinity of Cadaqués.* Cleveland: Reynolds Morse Foundation, 1954.

———. *The Draftsmanship of Salvador Dali.* Cleveland: The Salvador Dali Museum, 1970.

———. *A New Introduction to Salvador Dali.* Cleveland: Reynolds Morse Foundation, 1960.

———. *Dali, A Collection.* Cleveland: The Salvador Dali Museum, 1972.

New York, Gallery of Modern Art, Including the Huntington Hartford Collection. *Salvador Dali, 1910–1965, with the Reynolds Morse Collection,* Exhibition catalogue. New York: 1965.

Oriol, Anguera A. *Mantira y verdad de Salvador Dali.* Barcelona: Ediciones Cobalto, 1948.

Rey, Henri-François. *Dali dans son labyrinthe.* Paris: Grasset, 1974.

Soby, James Thrall. *Salvador Dali.* New York: The Museum of Modern Art, 1941; Simon and Schuster, 1946.

Tapié, Michel. *Dali.* Paris: Editions du Chêne, 1957.

Tokyo, Prince Hotel Gallery. *Salvador Dali Exhibition, Japan 1964.* Exhibition catalogue. Tokyo: Mainichi Newspapers, 1964 (in Japanese, English, French).

Utrillo, Miguel. *Salvador Dali y sus enemigos.* Sitges-Barcelona: Maspe, 1952.

SELECTED WORKS WRITTEN AND ILLUSTRATED BY DALI

L'Amour et la mémoire. Paris: Editions Surréalistes, 1931.

Babaoua. Scénario inédit. Paris: Editions des Cahiers Libres, 1932.

Cinquante secrets magiques. Rev. ed., with postscript by Dali. Lausanne: Edita Denoël, 1974.

Conquest of the Irrational. New York: Julien Levy, 1935.

Dali by Dali. New York: Harry N. Abrams, 1970.

A Dali Journal, 1920. Cleveland: Reynolds Morse Foundation, 1962.

Dali on Modern Art: The Cuckolds of Antiquated Modern Art. New York: Dial Press, 1957 (in English and French).

Dali, Oui! Paris: Editions Denoël, 1971.

Dali's Moustache, with Philippe Halsman. New York: Simon & Schuster, 1954.

Declaration of the Independence of the Imagination and the Rights of Man to His Own Madness. New York: Privately published, 1939 (single sheet).

Dix recettes d'immortalité. Paris: Audouin-Descharnes, 1973.

La Femme visible. Paris: Editions Surréalistes, 1930.

Fifty Secrets of Magic Craftsmanship. New York: Dial Press, 1948.

Hidden Faces. New York: Dial Press, 1948.

Le Journal d'un génie. Paris: La Table Ronde 1964.

Ma révolution culturelle. Tract distributed to the students of the Sorbonne, Paris, May 18, 1968 (single sheet).

Manifeste mystique. Paris: Robert J. Godet, 1951.

Les Métamorphoses érotiques. Lausanne: Edita, 1969.

Metamorphosis of Narcissus. New York: Julien Levy Gallery, 1937.

Le Mythe tragique de L'Angélus de Millet. Paris: Jean-Jacques Pauvert, 1963.

Open Letter to Salvador Dali. New York: J. H. Heineman, 1967.

Les Passions selon Dali, with Louis Pauwels. Paris: Editions Denoël, 1968.

Pujols per Dali. Barcelona: Editional Ariel, Fundación Picasso-Raventós, 1974.

The Secret Life of Salvador Dali. New York: Dial Press, 1942.

SELECTED WORKS BY OTHER AUTHORS ILLUSTRATED BY DALI

Alarcón, Pedro A. de. *Le Tricorne.* Monaco: Editions du Rocher, 1959.

La Bible, 5 vols. Milan: Rizzoli, 1967–69.

Breton, André. *Le Revolver à cheveux blancs.* Paris: Editions des Cahiers Libres, 1932.

——— *Second manifeste du surréalisme.* Paris: Editions Kra, 1930.

———, and Paul Eluard. *L'Immaculée Conception.* Paris: Editions Surréalistes, 1930.

Cellini, Benvenuto. *Autobiography.* Garden City, N. Y.: Doubleday, 1946.

Cervantes, Miguel de. *Don Quichotte.* Paris: Joseph Forêt, 1957–59.

———. *Don Quixote.* New York: Random House, 1946.

Char, René. *Artine.* Paris: Editions Surréalistes, 1930.

Dante. *La Divine Comédie,* 6 vols. Paris: Les Heures Claires, 1963.

Eluard, Paul. *Nuits partagées.* Paris: G.L.M., 1935.

Fages de Climent, C. *Les Bruixes de Llers.* Barcelona: Editorial Poliglota, 1924.

Hugnet, Georges. *Onan.* Paris: Editions Surréalistes, 1934.

Lautréamont, Comte de (Isidore Ducasse). *Les Chants de Maldoror.* Paris: Albert Skira, 1934.

Malraux, André. *Roi, je t'attends à Babylone . . .* Geneva: Albert Skira, 1973.

Mao Tse-tung. *Poèmes.* Paris: Argillet, 1967.

Pujades, J. Puig. *L'Oncle Vicents.* Barcelona: Editorial Poliglota, 1926.

Saint-Jean de Patmos. *L'Apocalypse.* In collaboration with six other painters. Paris: Joseph Forêt, 1960.

Sandoz, Maurice. *Fantastic Memories.* Garden City, N.Y.: Doubleday, 1944.

Tzara, Tristan. *Grains et issues.* Paris: Les Editions Denoël et Steele, 1935.